IMAGES
of America

BUELLTON

IMAGES
of America

BUELLTON

Historically Yours!
Curt Cragg

Curt Cragg and
the Buellton Historical Society

ARCADIA

Published by Arcadia Publishing
Charleston SC, Chicago IL, Portsmouth NH, San Francisco CA

Printed in the United States of America

Library of Congress Catalog Card Number: 2005932375

For all general information contact Arcadia Publishing at:
Telephone 843-853-2070
Fax 843-853-0044
E-mail sales@arcadiapublishing.com
For customer service and orders:
Toll-Free 1-888-313-2665

Visit us on the Internet at www.arcadiapublishing.com

CONTENTS

ACKNOWLEDGMENTS

It would be impossible to tell the story of a community without the help and participation of the community and its members. Fortunately, some of the residents and former residents of Buellton are passionate about their history and willingly shared their images and stories to make this publication possible.

First, this book can be attributed to Phyllis Lotz for her tireless effortless over the past 13 years. She is a champion of Buellton's history, from the inception of the Buellton Historical Society in 1992 until her retirement in 2005.

A thank-you is also due to the following people who have recently supported my efforts at adding historical documents to the archives of the Buellton Historical Society and ultimately this book: Willie Norlin and Jim Buell, Buell Ranch and family photographs; Howard and Mavis Jensen, personal photographs and historical background; Kathryn Lauritzen Garland and Martha Atkins, early Buellton history and photographs; Jack, Mark, and Vickie Mendenhall, for the service town, racing, and Andersen's Pea Soup information; Robby "Pea Soup" and Sherry Andersen, for Andersen's Pea Soup and family; the *Santa Ynez Valley News* archives; and the Santa Ynez Valley Historical Society.

Finally, a thank-you goes to Joy Chamberlain, John Fritsche, Alan Fox, and highway historian David Cole for directing me to the many postcard images and ephemera covering Buellton and the local area.

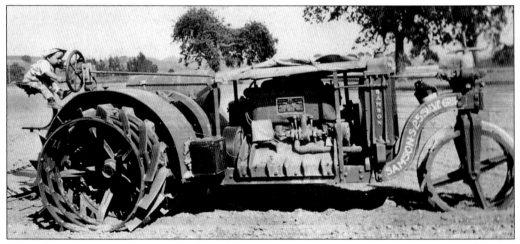

Young Peter Lauritzen prepares to plow the fields on the Lauritzen family farm, *c.* 1920s. Dry farming was a staple of the early farming operations in Buellton, often growing grain to feed the many dairy and beef cattle on the surrounding ranches.

INTRODUCTION

This book is by no means intended to be a comprehensive history of Buellton. The pictures and captions are merely windows with views of some of the significant or interesting times that have created this community. When looking through the glass, one gets a glimpse of the inside, but cannot see the entire house. Likewise, each of these pictures will only tell a windows worth of the story. A close look at the images reveals even more about the town and the stories within the windows.

In the first window is the Buell Ranch and the Buell family. This family, and the patriarch Rufus Thompson Buell, owned a significant portion of land upon which the town was eventually established. Even before Buellton, the ranch supported a town of its own due to the sheer size of the operation.

There are views of the development of a major highway along the coast of California. The El Camino Real was developed long before the automobile as the padres established the missions in California. In addition to the padres' missions, there were way stations for stagecoaches. As the use of the automobile expanded in the early 1900s, there was an increasing need for services and "good roads" for the oncoming motorists.

In the early 1910s, the State Highway Department sent surveyors up the coast of California looking for ways to straighten out and improve the old El Camino Real for the modern automobile. The Buell Ranch laid in the path of a straighter road from Los Angeles to San Francisco.

Intent on making the road more drivable, new bridges were built and roadways paved before and after World War I. One of the last sections of the Coast Highway to be paved was in the emerging service town of Buellton, located at a crossroads of two missions and the coastal route. In 1922, the paving of the last section of the highway resulted in a major celebration, attracting thousands of people to the small, growing town.

In 1924, a small diner opened at the crossroad of this new town and grew to worldwide fame on the merits of one simple dish—split pea soup. The Andersen's Electrical Café was built upon a solid foundation of this now famous split pea soup, outlasting a major highway and serving millions of travelers in the process. There are pictures of the pea-soup empire as it grows, expands, and changes, while serving soup for over 80 years.

Buellton was not built upon Andersen's alone. Many service businesses were established along this stretch of the Coast Highway to serve the onslaught of travelers moving up and down the coast of California. In 1948, following World War II, the sheer volume of this travel necessitated the widening of the highway through the town of Buellton. The town was rearranged to make way for the wider road. Significant changes occurred to the small service town, including the addition of new service stations, motels, and diners, earning the town the designation of "Service Town, U.S.A."

These are some of the windows in this home called Buellton. Travel along the coast of California to this service town in Santa Barbara County and see what the windows reveal.

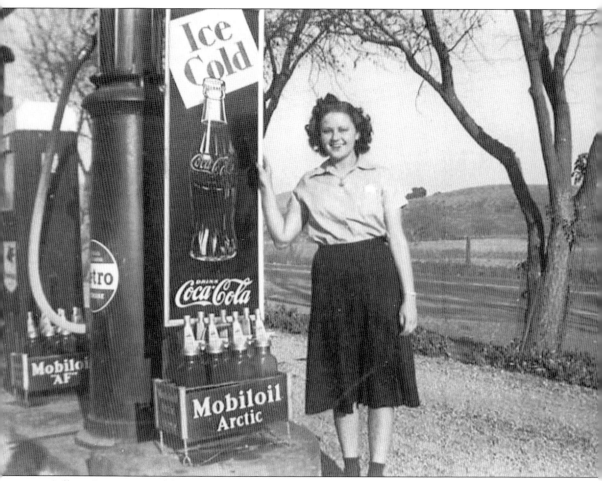

Lillian Brus poses at the pumps in front of her family's small Mobil service station. The Brus family operated the station and the Sun Valley Auto Court on the southbound lanes of the Coast Highway (101) in Buellton around 1939.

One

BUELLTON'S BEGINNINGS

Following the rush to find gold, young Rufus Thompson Buell, known as R. T., came from Essex, Vermont, to California in 1853, searching for his share of the wealth. He traveled on a sailing ship around Cape Horn from New York to San Francisco. Upon his arrival, he set out in search of gold at Bidwell's Bar on the Feather River in Sonoma County. Realizing that seeking gold was hard work with minimal return, he soon turned to his given trade of farming to support himself. Having come from a family of farmers in Vermont, he quickly succeeded, first in the bottom lands of the Feather River in Sonoma County and then moving on to Point Reyes in Marin. He founded a successful dairy operation in 1857 and farmed there until he bought a larger parcel of land in Monterey County near Salinas in 1865.

In the Salinas Valley, R. T.'s dairy herd grew to 800 head of cattle. While there, his brother Alonzo Wilcox Buell traveled the overland stage route to California from Vermont, preferring a long wagon trip to a sailing adventure. He was attracted in part by the prospect of buying land with his brother. In 1867, the Buell brothers purchased approximately 26,000 acres of the Rancho San Carlos de Jonata in Santa Barbara County from Jose Covarrubias and Juan Carrillo.

R. T. continued operating the dairy farm in Salinas, while Alonzo began establishing the ranch in the Santa Ynez Valley. Eventually R. T. decided to move his entire operation to Rancho San Carlos. He bought out his brother in 1872 and quickly began developing the property further, creating a virtual town within the ranch.

A portion of the ranch would eventually become the real town, but not until after R. T. Buell died in 1905, leaving the ranch subdivided in seven sections to his heirs.

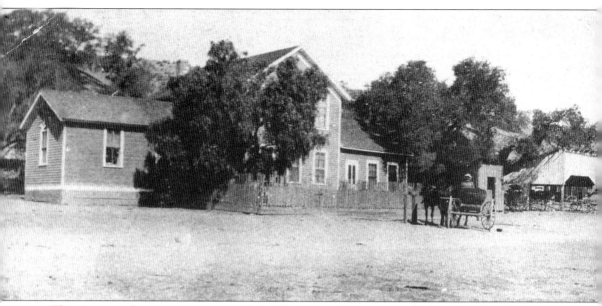

This is an early panoramic view of the Buell family house overlooking the Buell farming operation to the right. At its peak, the ranch grew wheat and grains on 4,200 acres and housed 1,200 dairy cows, 3,500 head of cattle, 1,700 sheep, 700 hogs, and 150 horses. There was a cheese

The Buell family ranch house was located near the north end of what today is Central Avenue in Buellton. Pictured in front are Mr. and Mrs. James Budd, parents of R. T.'s third wife, Emily Budd, with two of the Buell children. Behind them, along the fence, are Mrs. Budd's twin aunts Mrs. Hugh Griffith and Miss Carolyn Stubbs. On the porch are R. T. Buell and his wife, Emily Budd Buell. This original Buell house was lost in a 1921 fire.

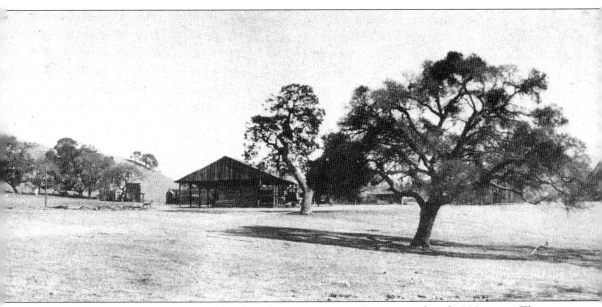

factory, a dairy operation, an orchard with 1,400 trees, and a vineyard with 800 vines. There was also a blacksmith shop, general store, and post office, making the ranch almost entirely self-sustaining. It was a town within itself.

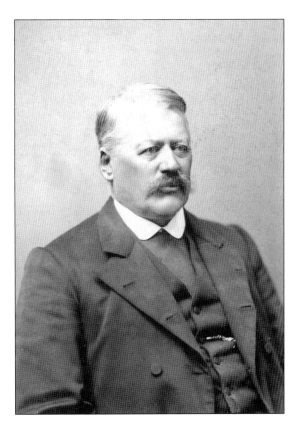

Rufus Thompson Buell was an educated farmer and rancher who finished college in Ohio before coming to California in search of gold. In addition to farming, he practiced law in San Francisco and edited a newspaper while in Salinas. Most importantly for the local area, he bought property in the Santa Ynez Valley, part of which became his namesake, the town of Buellton.

Linus Buell was the only surviving child from R. T.'s second marriage to his cousin, Helen Goodchild Buell. Born on October 2, 1868, in Salinas, Linus moved to the Buell Ranch with his family when he was still a young child. He spent the rest of his life on the Buell Ranch until he passed away in August 1931.

Linus married Anna May Smith of nearby Ballard on April 4, 1892. Until Linus's death in 1931, they raised three of their own children as well as an adopted son, Edison, on the Buell Ranch.

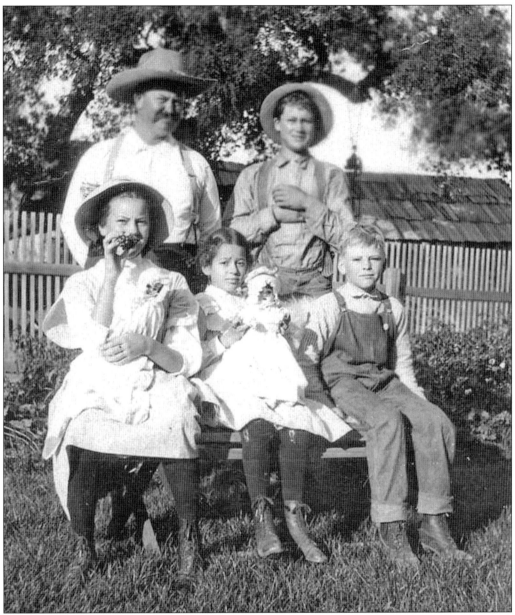

Linus raised his own family on the ranch along with his younger brothers and sister. In addition to his own children, Linus had four much younger siblings from his father's third marriage to Emily Budd in 1892. Pictured, from left to right, are (first row) Linus's daughter Ada, born July 1895; Linus's half-sister Gertrude, born in 1899; and his son Edward, born in 1898; (second row) Linus and his son Frank, born in October 1893.

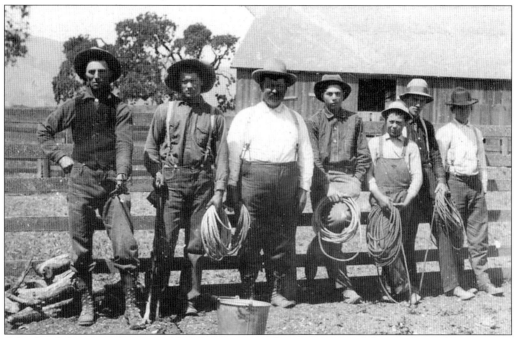

After his father passed away in 1905, Linus assumed management of the ranch until his younger siblings came of age. Ranch management included overseeing a large dairy and farming operation as well as the ranch hands needed to run the place. This image depicts Linus, middle in a white shirt, with oldest son Frank to his left and some of the young ranch hands with their prized handmade ropes.

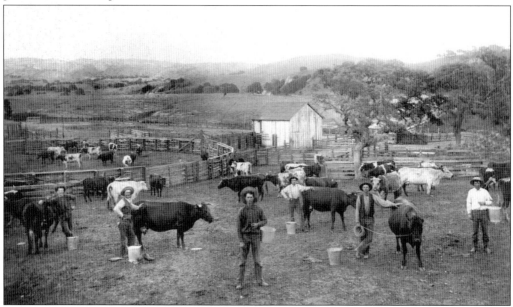

Milking time at the Buell Ranch required a large contingent of hands to milk the cows. The Buell Ranch was a dairy farm first, with 1,200 cows at its peak. Dairy production would continue to be a staple of the Buellton area and nearby Solvang well into the 1950s, although much of the Buell property was primarily used for grazing and dry farming after the 1930s.

Hunting was a favorite pastime of Linus Buell and many of the other Buell boys. The surrounding hills and valleys were abundant in deer, with an occasional bear or mountain lion. Venison also provided a much-needed change from the ranch staples of chicken and beef. Note the large rack of antlers hanging from the wagon near the center of the picture. Linus is standing in front of the wagon on the far right.

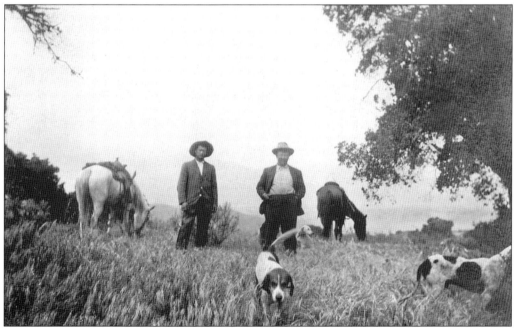

Frank and Linus may have been out for a leisurely ride in the hills above the ranch or on a hunt with the dogs. With approximately 16,000 acres of ranch to cover, horseback was the mode of transportation for checking fences and keeping an eye on the cattle.

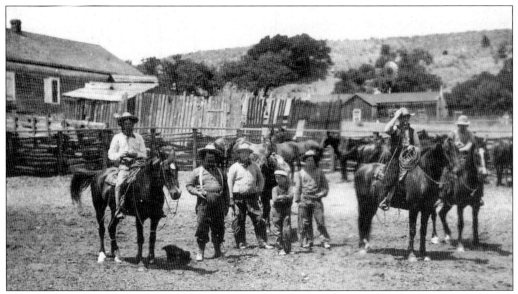

These ranch hands are getting ready for round up or branding as they pose at the rails. Keeping track of all of the cattle required regular round ups and branding, making it an important time on the Buell Ranch. When the cattle were ready for market, they were driven south through the Gaviota Pass and shipped off to points north and south.

A blacksmith shop on the ranch kept the horses in shoes and the ranch equipment running. The smithy shop was an important asset to a ranch the size of Buell's, with a steady supply of work building and repairing equipment and shoeing horses.

There were plenty of young Buell boys in training for ranch duty by 1905, including uncles and nephews all of about the same age. Pictured, from left to right, are (first row) R. T.'s son Walter; (second row) Linus's son Frank, R. T.'s son Glenn, Linus's son Eddie, R. T.'s son Odin; (third row) Emily Budd Buell, R. T.'s third wife, and R. T.'s son Rufus Jr.

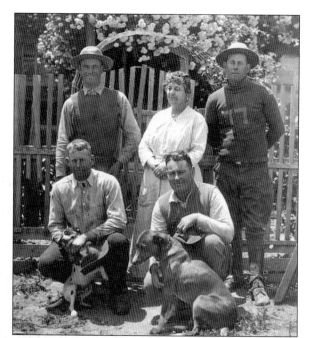

When R. T. Buell died in 1905, he left his oldest son Linus in charge of the ranch. His will provided for the approximately 16,000-acre ranch to be subdivided into seven sections when his youngest sons came of age. As it turned out, the two oldest of the youngest sons were called to service in World War I, so the ranch was subdivided in 1913, before their departure. Pictured here, from left to right, in the early 1920s, the youngest boys, now young men, are (first row) Glen and Odin; (second row) Walter, mother Emily Budd Buell, and Rufus Jr.

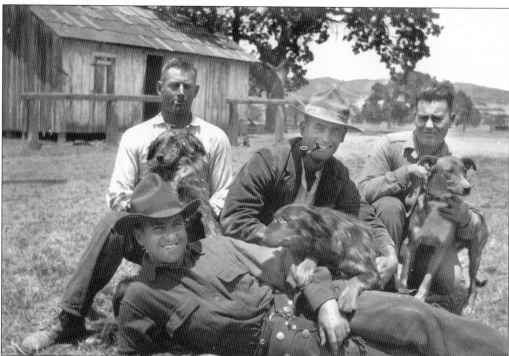

Having benefited from the hard work of their father and older brother by the 1920s, the youngest Buell boys did not have to work the ranch with the same intensity after it was subdivided. From growing up on a ranch, they were all competent horsemen, and they enjoyed rodeo, hunting, and occasionally chasing cattle. Their mother had subdivided her portion of the ranch into a burgeoning new town by 1917, so the boys were able to enjoy a little bit of town life as they came of age too—either in their own town or in nearby Los Olivos, Santa Ynez, or Solvang.

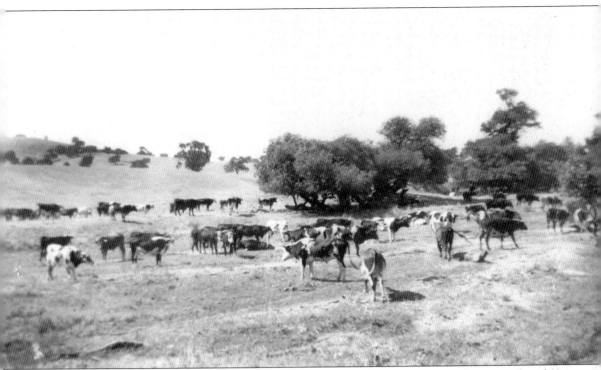

The Buell Ranch was a large cattle operation running 3,500 head at its peak. Even after the ranch was subdivided, all of the Buell boys continued to raise their share of the cattle on their portion of the ranch property. Even today, cattle ranching is a primary operation on property owned by Jim Buell, grandson of R. T. Buell.

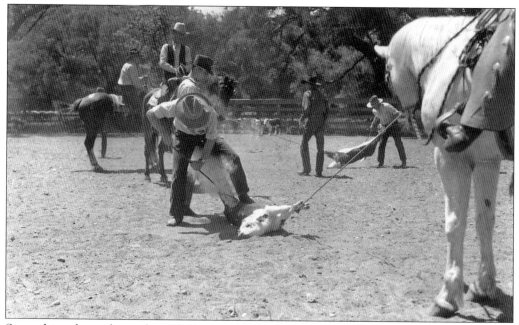

Some things have changed very little in over 100 years of ranching on the Buell Ranch. Round up and branding are still carried out in the traditional way, although sometimes the horses and cowboys now arrive by truck and trailer to the range. It is difficult to tell which Buell brand is being applied to this little doggie, since each portion of the ranch and each brother had their own brand after R. T.'s death and the subdivision of the ranch around 1913.

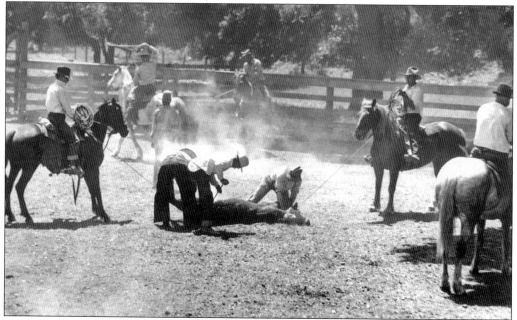

Round up is a lot of work, but for the cowboys it is also a time of camaraderie and competition. A working cowboy has the opportunity to showcase his roping and penning skills amidst his peers. The modern rodeo competitions give testament to the value of competent cowboy skills. The Buell boys were all good with a rope and saddle, having grown up in the cowboy way.

Rustic outbuildings, barns, and sheds were a staple of the Buell Ranch properties, as with all ranches. Crooked buildings, like this one built in the late 1800s and early 1900s, still provide shelter for tools and equipment on portions of the original Buell Ranch today. Despite looking like they would blow over in the first wind, these ranch buildings are a testament to utilitarian ranch life and the timelessness of the Buell Ranch.

Odin Buell inherited the northeast portion of the Buell Ranch. Like the other six sections of the ranch, "La Rancheria" consisted of approximately 2,300 acres. Today Odin's son Jim Buell owns the ranch, the last of the Buells to retain their interest in the original ranch that was subdivided to the heirs in 1913.

Each of the Buell boys owned homes built on their portions of the original Buell Ranch. The

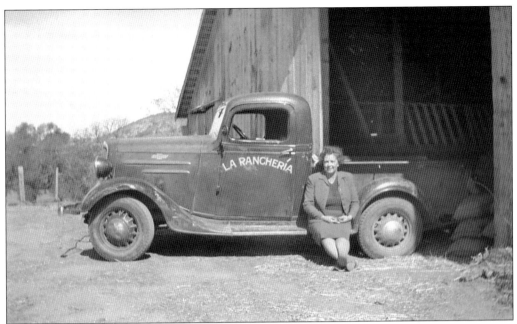

Josephine Buell, Odin's wife, perches on the running board of this now tired ranch truck. This barn, with the fold down hayloft, is still in use on the ranch today, although Josephine and the truck are gone.

oak-studded hills provided a scenic background for this Craftsman-style ranch house, c. 1930.

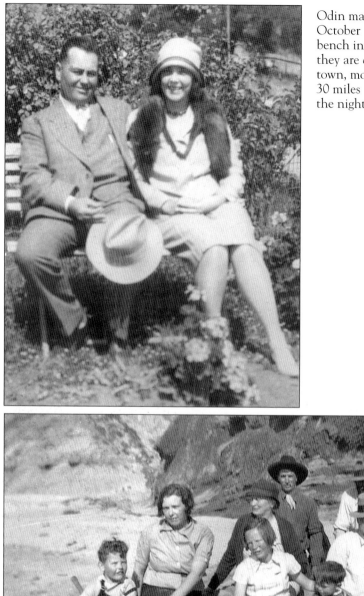

Odin married Josephine Thomas on October 8, 1925. Pictured here on a bench in front of the ranch house, they are dressed for a night on the town, most likely in Santa Barbara, 30 miles to the south, where most of the nightlife was in the 1920s.

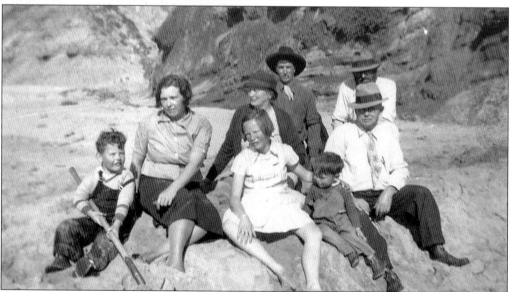

Gaviota Beach was a popular place for picnics and family gatherings. It was the closest beach to Buellton, 15 miles south on the Coast Highway. Here Odin's family and in-laws pose for a picture. Pictured here, from left to right, are (first row) Tommy Buell; Josephine Buell; Rose Budd, daughter of William "Billy" Budd, and Jim Buell; (second row) Odin's mother, Emily Budd Buell; and her brother William "Billy" Budd; (third row) unidentified ranch hands.

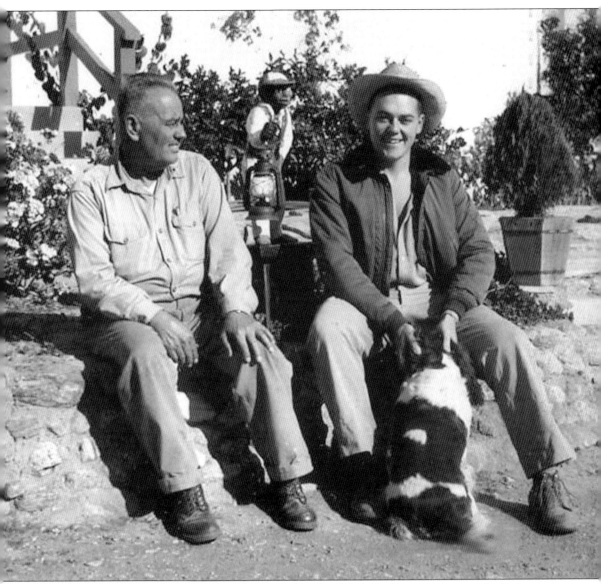

Odin and Jim share a moment at the ranch. Jim Buell left Buellton to serve with distinction in the air force and later earned a doctorate degree in veterinary medicine. After graduating, he bought 800 acres of the family ranch and, in the 1970s, bred thoroughbred racehorses. He inherited the rest of the ranch when his parents passed away. Today the ranch is primarily used to raise beef cattle under the supervision of ranch manager Willie Norlin. Jim Buell's La Rancheria is the last section of the original Buell Ranch, still under family ownership.

This picture could have been taken yesterday or in 1910, as little has changed on some portions of the Buell Ranch. Horses, cattle, barns, and outbuildings are still a way of life, just as they were in the 1800s when R. T. Buell first developed the ranch, portending the future of what would become Buellton.

Two

BUILDING BRIDGES

In the early 1900s, the automobile was sputtering to life. The coast of California was an ideal place to experience highway travel, with perfect weather almost year round. As the early auto adventurers discovered the open road, a new century of travel was dawning throughout the Golden State.

Of course the initial experience of the motorist was not nearly as glamorous as it sounded. These early machines could be very temperamental, requiring frequent tinkering and service along the way. Not only that, the road conditions in some places were deplorable at best, consisting of rutted paths well worn by wagon wheels and horses hooves.

That became notable when one left the larger cities to travel up the coast of California in search of open roads and adventure. The Coast Highway from Los Angeles to San Francisco was certainly an adventure in 1911, especially when one left the coastline and made the turn into the Gaviota Gorge, north of Santa Barbara.

The Automobile Club of Southern California lobbied the recently formed State Highway Department to make improvements to the antiquated roads. Having an efficient path of travel along the coast of California was undoubtedly one of the top priorities of both entities, and they quickly started making plans to bring it about. Survey crews were sent into the fields to make plans for straightening the winding road and creating the shortest distance between two points, namely Los Angeles and San Francisco.

In 1913, a survey crew arrived in the central part of Santa Barbara County. From their survey, they determined that two obstacles lay directly in the path of achieving their objective of straightening out the road along the Central Coast of California. One was manmade in the form of property lines, laid out in the previous century and easily overcome. The other was natural and presented a more monumental challenge.

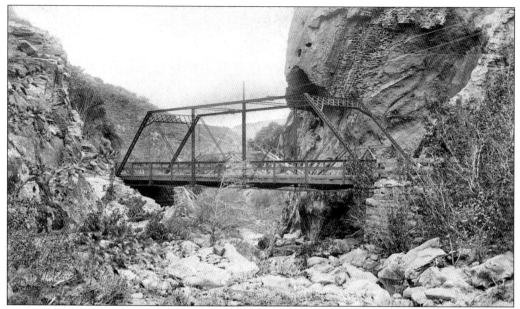

The Gaviota Gorge is the entrance to the Santa Ynez Valley from the south as one leaves the coastline and heads into the coastal valleys. The early motorists arrived at a steel truss bridge starting around 1911. The path that lay ahead was a meandering one, following old stagecoach routes and the early El Camino Real of the missions.

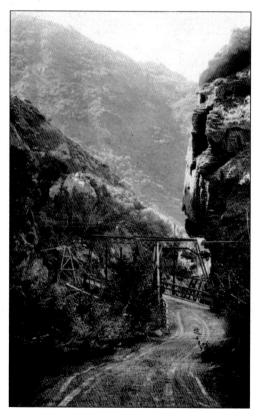

The bridge was narrow, and for motorists, it could be impassable if they arrived during cattle drives from the north. They might have a long wait as ranchers like the Buells drove their cattle into the mouth of the gorge on the way to the wharf at Gaviota for shipping to points north and south.

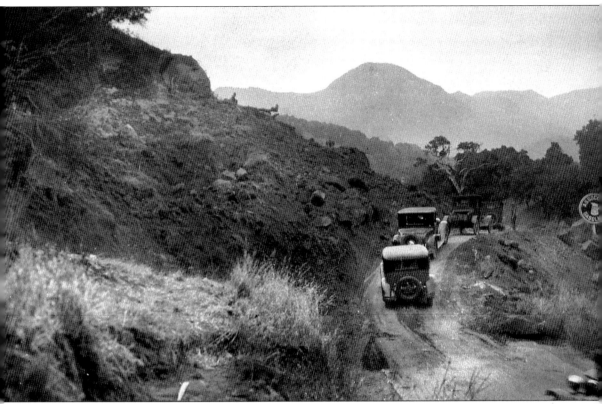

Early automobiles often encountered livestock, bumpy dirt roads, constant washouts, and construction. The road tended to follow the meandering streams and foothills, which required less grading for the early road builders but were not the most direct routes between points. As the automobile became more popular, there was more pressure and motivation to improve the roads and straighten them out for speed and efficiency of travel.

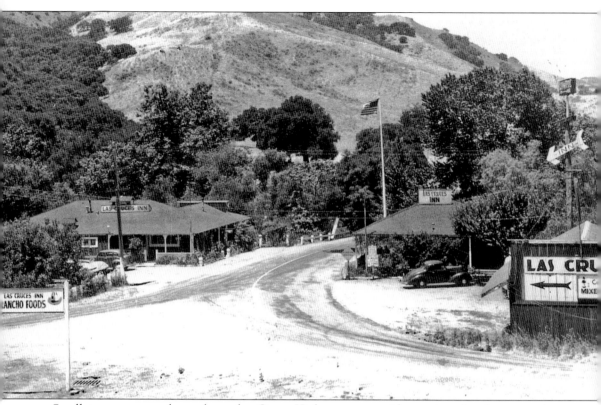

Small towns sprouted up along the Coast Highway to provide services for the oncoming motorists. Some towns, such as Las Cruces, existed for the stagecoaches that preceded the automobile. Las Cruces was located at a Y intersection on the Coast Highway, going northwest to the Lompoc Valley or heading around the Nojoqui Grade and eventually winding into the Danish town of Solvang from 1911 to 1917.

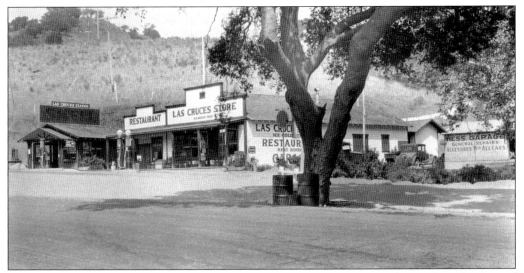

The west side of Las Cruces existed before the automobile. The east side came about because of the automobile. Due to the frequency of servicing required for these temperamental early autos, small two-pump service stations and garages popped up at 15-mile intervals along the coastal route. Las Cruces was the first town along the way as one rounded the Gaviota Pass heading north into the Santa Ynez Valley.

From Las Cruces, the Coast Highway wound around the Nojoqui Grade heading east along the back side of the Santa Ynez Mountains toward the town of Solvang. That route is still drivable today by taking the Nojoqui Park turnoff from the northbound Highway 101 and following it to the Alisal Guest Ranch, across the Santa Ynez River, and into the city of Solvang.

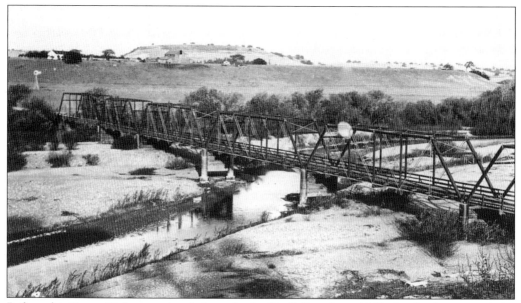

Before the Coast Highway existed through the Buell Ranch in 1917, this bridge crossed the Santa Ynez River into the Danish colony of Solvang. Solvang was once the main intersection of the Coast Highway and the mission road that traveled from Mission Santa Ines at the edge of the Danish Colony to Mission La Purisima on the outskirts of the Lompoc Valley. A new bridge, built over the Santa Ynez River in 1917, permanently altered this intersection, relocating it about eight miles to the west in Buellton.

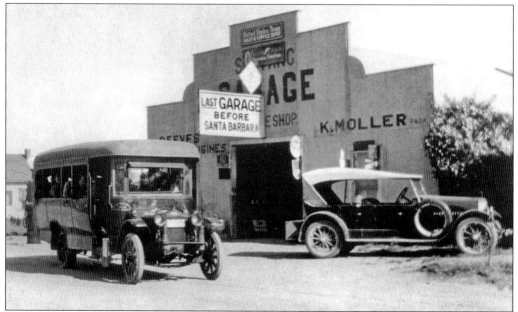

Knud Moeller would be one of the first to take advantage of both intersections. Around 1911, he established one of the first service stations and garages in the town of Solvang. When it became apparent that this intersection would no longer be the primary crossroad, he opened a second garage and service station in the new town in 1917. His business was one of the first in the new town that would officially become Buellton in 1920. Pictured here is Knud Moeller's Solvang garage.

Mission Santa Ines was the reason for the original route of the El Camino Real in Santa Barbara County. As stagecoaches and automobiles took to the road, they naturally followed the already established route. Around 1913, the State Highway Department surveyed Santa Barbara and determined that a straighter route existed for this section of the Coast Highway. The route ran right through the Buell Ranch, bypassing the mission and the town of Solvang eight miles to the west.

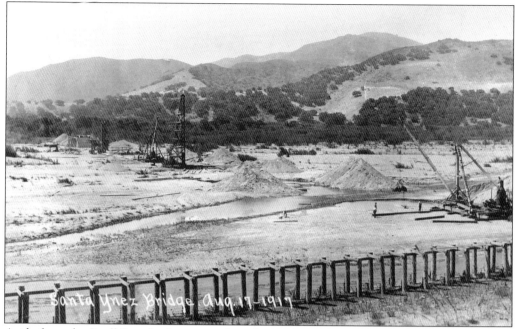

Aside from the Buell Ranch, the major obstacle to a revised route for the Coast Highway was the breadth of the Santa Ynez River. Despite the small stream of water in the middle of this wide wash, the locals knew that this river had the potential to run deep and wide in stormy seasons. A long bridge would be needed to cross the river. Work on the bridge began in 1917, soon after the end of World War I.

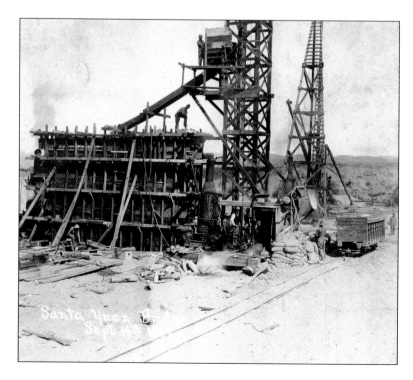

The bridge would span the river and two large ranches—the De La Cuesta Ranch to the south and the Buell Ranch to the north. Roman De La Cuesta had been involved in lobbying the State of California to locate the highway through his ranch. This image shows the formwork required to build the bridge supports. Very little large timber was available locally so most of it had to be shipped to the Gaviota Wharf and hauled to the site.

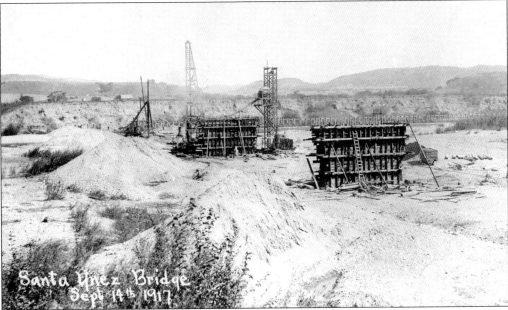

By September 1917, this photograph from the California Department of Transportation archives shows the support forms marching toward the northern riverbank and the Buell Ranch. All of the concrete was manufactured in the riverbed, as no local concrete plants existed at the time.

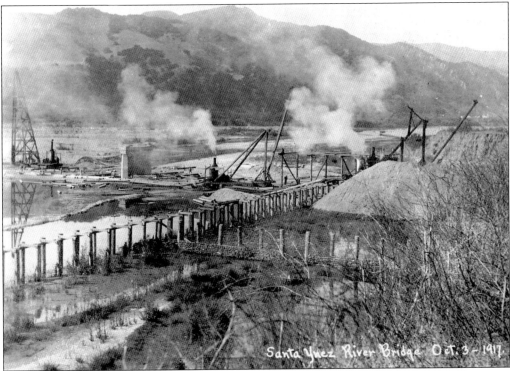

By October, the forms were stripped away and the first steel supports were being erected to carry the spans. Fortunately for the construction crew, it appears that the fall of 1917 was relatively dry, allowing work in the riverbed to proceed.

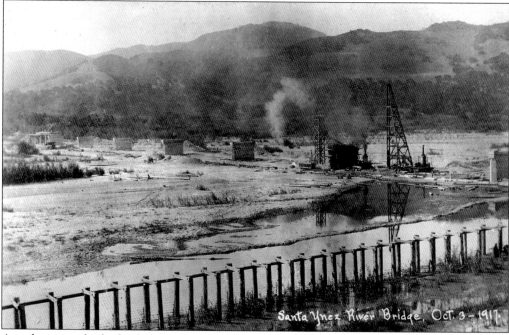

A railway was built the length of the construction in the river to transport materials back and forth along the bed. This type of bridge building had typically been used on the rail lines before the advent of the automobile and therefore was a well-established and time-tested method of construction.

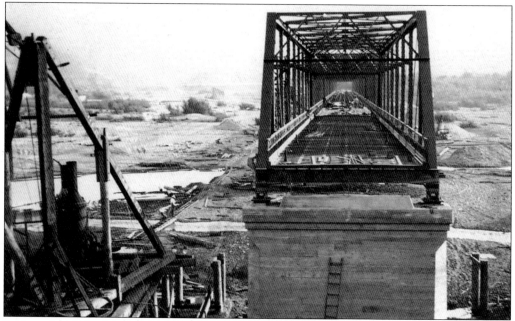

By late October, the spans were being installed. A view down the platform from the Buell Ranch shows the interesting ironwork that made up the sections of the bridge. The bridge would forever change the course of the Coast Highway in this part of California. It was also the catalyst for the creation of a new town.

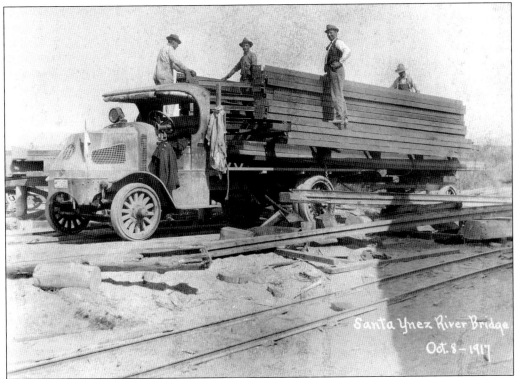

A special heavy-duty truck hauled the ironwork across the riverbed to complete the construction of the spans. The iron was most likely shipped from San Francisco down the coast to Gaviota Wharf, where it was unloaded and hauled to the site along the Gaviota Pass and Nojoqui Grade.

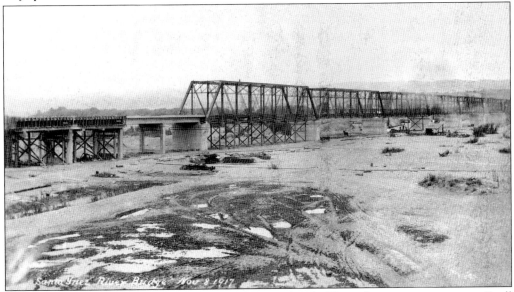

By early November, the bridge was nearly completed. Plans for a new town on Buell Ranch property were in the works as a new roadway was laid in anticipation of the opening of the bridge.

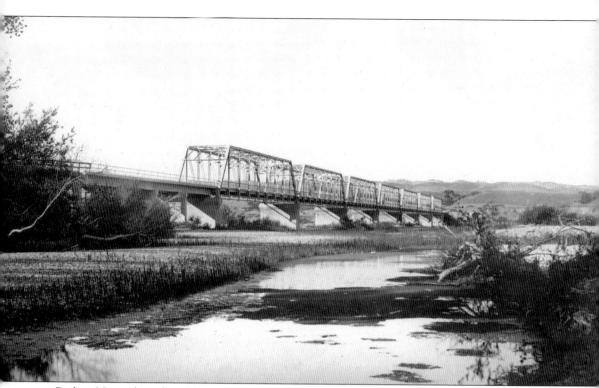

By late November, the ribbon was cut, allowing access to the new route of the Coast Highway through the center of Santa Barbara County. A new town was established, just to the north on Buell Ranch property, and the first small service businesses opened in anticipation of the onslaught of traffic.

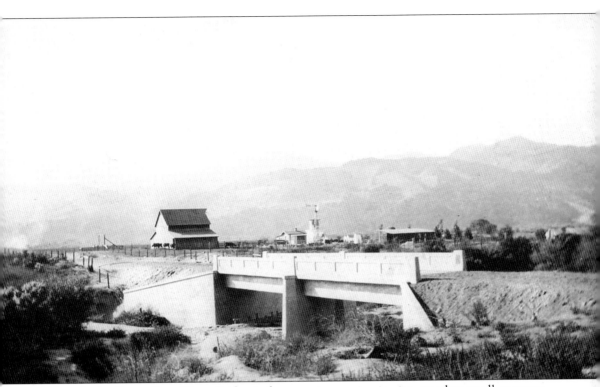

Although the Santa Ynez River Bridge is far more impressive in size, another small concrete bridge, built in 1917, was also an important link to the new town. The Zaca Creek Bridge was actually the last bridge used before entering the new town from the south. Like a majority of the towns on the new Coast Highway, a dirt road ran through it in 1917.

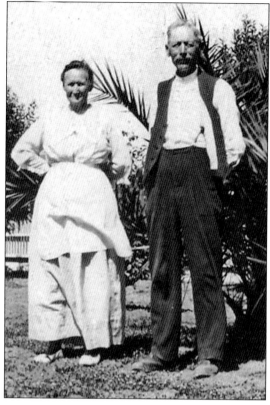

Mads Freese, shown here with Mrs. Freese around 1920, was a "land man" and one of the original founders of Solvang in 1911. A land man in Freese's day was the equivalent of a real estate agent and developer today. Along with R. T. Buell's third wife, Emily Budd Buell, and her brother William "Billy" Budd, Freese helped lay out the town that became Buellton.

William "Billy" Budd was the first general merchandise storeowner in the new town. He was also the postmaster and housed the first post office in his store. Budd applied for the name "Buell" with the U.S. Postmaster General, but it was already in use in Oregon. His second request, Buellton, was finally accepted and became official in 1920, almost three years after the town was established.

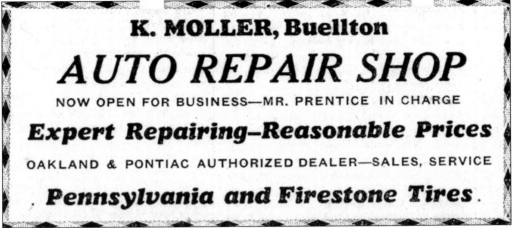

Most likely, the first garage and service station in Buellton was Knud Moeller's place on the corner of the intersection of the new Coast Highway route and Mission Road. This station would only be the beginning of what fast became one of the larger service towns along the highway.

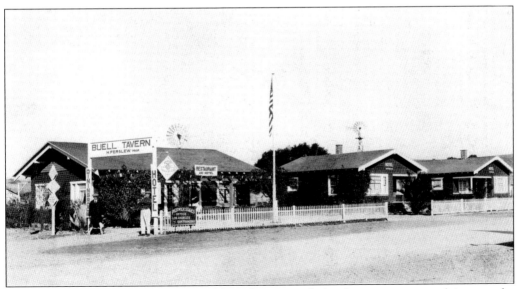

Across the street from Moeller, Harold Ferslew opened the first restaurant and inn on the northwest corner of the new town. Like Moeller's Garage, it was only the first of many such establishments in the new service town.

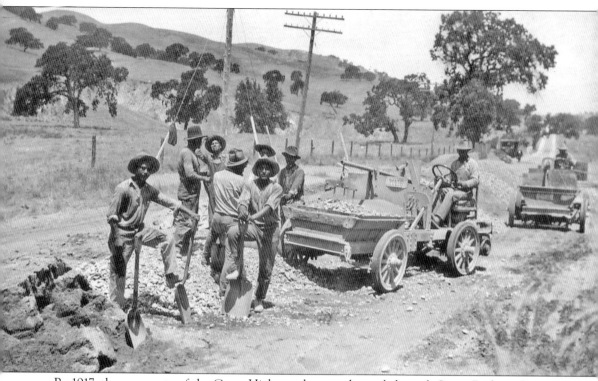

By 1917, the new route of the Coast Highway shortened travel through Santa Barbara County. It was a significant improvement for the oncoming automobiles. There was still one major drawback, however, for the balloon tire motorcars. It was still a dirt road, composed of sometimes-sharp pieces of shale, and early motorists suffered the setback of frequent flats. For the newly established garage owners, the need for tires as well as other services held the promise of good business along the road for years to come. In 1917, the owners had no idea just how good it could be.

Three

PAVING THE WAY

Just as the Roaring Twenties were dawning in America, the new town of Buellton was becoming established on the Coast Highway in Santa Barbara County. Since the subdivision of the Buell Ranch among the heirs in 1913, things had changed significantly.

There were now seven Buell ranches, of which one section had become most of a new town along the route of the realigned Coast Highway that opened late in 1917. The highway had brought businesses and business people into the town. New homes were built and services established to suit both the townspeople and the travelers.

These travelers, on their way up and down the coast of California, would become a significant factor in the survival of the new town, as would the actual highway itself. Getting the highway built was only the beginning, as significant changes to the highway in the decades to come would cause the town to grow and rebuild itself several times over.

Because of the highway, the town would forever be wed to the road and its future, with fortunes incumbent upon the whims of the road and its travelers. In 1920, it showed only hope and promise for a bright future. However, it still had one major drawback—it was dirt.

Like most of the Coast Highway in the rural parts of California, the road was in need of some improvement, primarily in the form of pavement. As the automobile was becoming significantly more popular and affordable for more Americans, improving the roads became a greater priority.

Pressured by the Automobile Club of Southern California's lobby for "good roads," the State Highway Department made plans to pave the entire Coast Highway from Los Angeles to San Francisco in the early 1920s. As it turned out, the schedule showed that the last place to be paved would be in the relatively new town of Buellton.

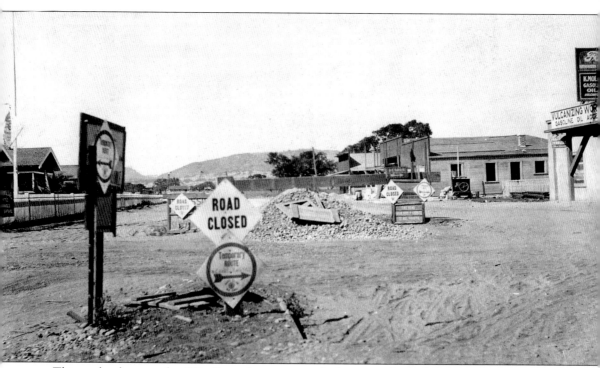

This early photograph of Buellton shows a view looking north on the Coast Highway (later known as Highway 101) at the intersection with the Mission Road (now Highway 246). On the left is Harold Ferslew's Buell Tavern and Inn. On the right is Knud Moeller's garage. Just to the north of Moeller's are some wood storefronts that would eventually be torn down and become the home of Buellton's longest-lasting business. The dirt road is detoured in preparation for paving.

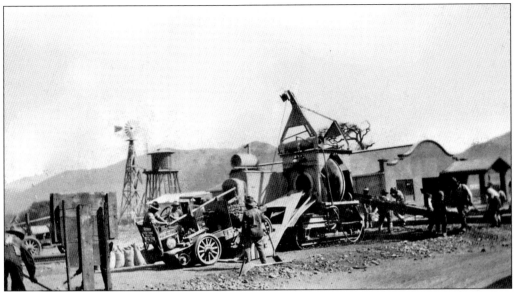

Early in 1922, paving crews moved through the town of Buellton. This paving operation was significant because it was one of the last sections of unpaved Coast Highway between Los Angeles and San Francisco.

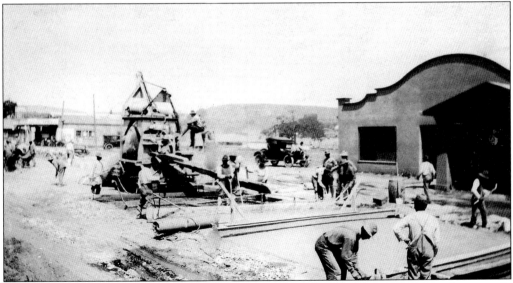

As the pavement was being laid on the last section of the Coast Highway, plans were being made for a celebration in Buellton to commemorate the momentous occasion. Throughout the state of California, invitations were sent inviting dignitaries to come to Buellton for the barbecue, baseball game, dedication, parade, and rodeo that recognized the event.

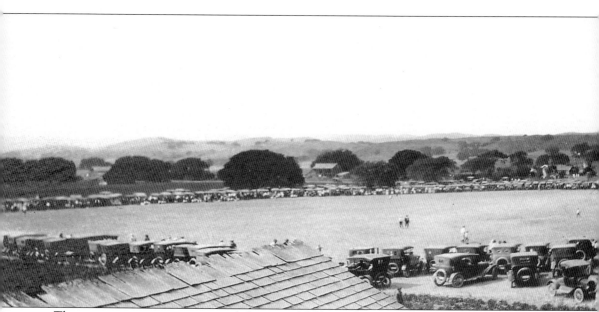

The newspaper accounts estimated that over 8,000 people attended the celebration in Buellton on August 27, 1922. Considering that the population of the whole town at the time was probably

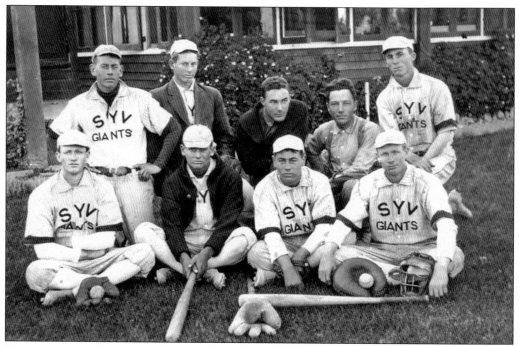

Was this the baseball team that represented Buellton? This picture of the Santa Ynez Giants team taken around 1917 has five Buells on it, so most likely they played in the game of 1922. Pictured, from left to right, are (first row) Delbert Brown, Walter Buell, Odin Buell, and Gilbert Brown; (second row) Rufus Buell, Glen Buell, Burt Mattei, Frank Mattei, and Harold Buell (a cousin of the other Buell boys).

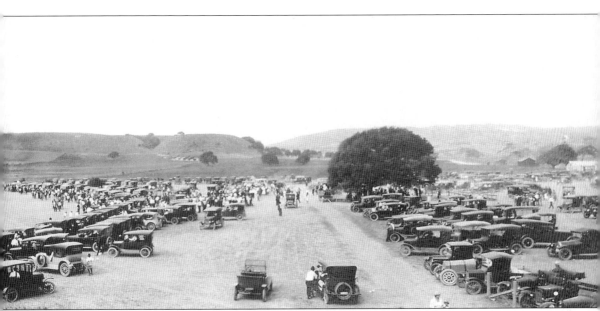

less than 100, this crowd was huge. A baseball game between the Santa Ynez Giants and a team from Shell Oil Company were part of the day's festivities.

The newspapers advertised a rodeo, but more likely it was a riding and roping exhibition. There was also a parade down the new highway to the bridge built in 1917, where a dedication took place featuring speeches and dignitaries from the state.

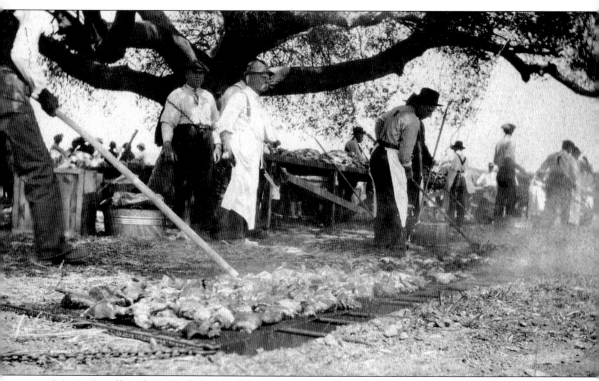

M. A. Botello, along with his barbecue crew, had the daunting task of feeding the masses. The barbecue pits were dug under the shade of a large oak tree on the Lauritzen Ranch. Ten cows were slaughtered, sacks of pinto beans boiled, and dozens of loaves of bread were served. Beginning at 11:00 a.m., the last scrap of food was served to the long lines around 3:00 p.m.

Over the next two decades, the service town of Buellton, with its newly paved highway, would begin to grow. The publicity from the paving celebration attracted new businesses and new travelers to support them. Motorists could now drive on paved roads from Los Angeles to San Francisco, and many of them did, needing services along the way.

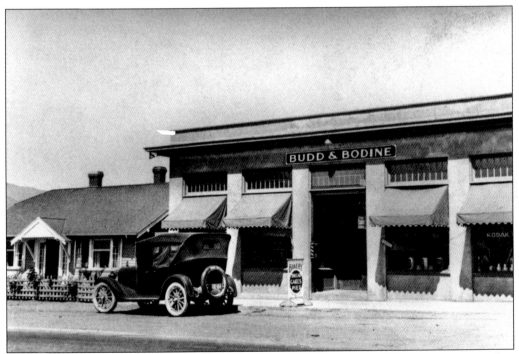

William "Billy" Budd soon vacated his store and partnered with Albert Bodine, another local store owner, "to build" a general merchandise store on the southwest corner of the new town. Their store would serve the town of Buellton into the mid-1950s, until it was passed on to a new owner. Even today, a market holds down the same location as this store established in the 1920s.

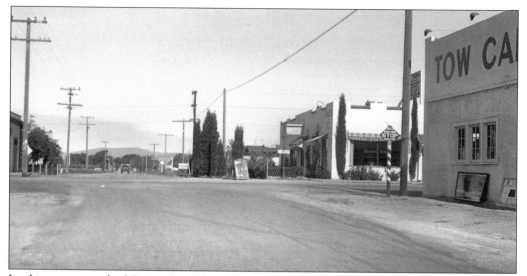

Looking west on the Mission Road (now Highway 246) toward Lompoc at the intersection of the Coast Highway (101), improvements to the growing service town are apparent. On the right is the Moeller Garage in the midst of a sign change to a new service station. Across the street is Harold Ferslew's new restaurant building in place of his old tavern and inn. Across the street from Ferslew's (on the left) is the corner of the Budd and Bodine Store.

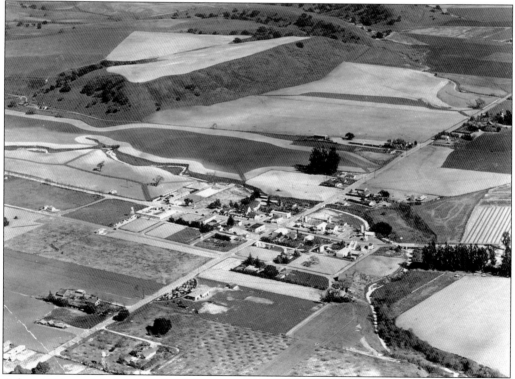

A late-1930s aerial photograph of the town shows how Buellton has grown. This view looks northeast, with the main intersection just to the right of center. The Mission Road runs diagonally from the left corner to the right corner.

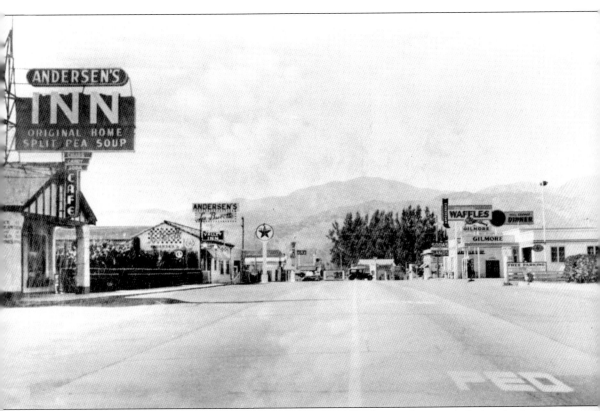

A street view from the middle of the Coast Highway looks south to reveal the Andersen's restaurant complex on the left, followed by a Texaco service station. Across the street on the left are several more service stations. On the right, a Gilmore gas station sits next to Ferslew's restaurant, then Budd and Bodine's store, and several more service stations.

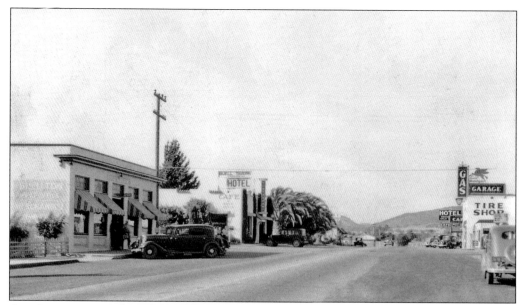

Another street view from the middle of the highway looking north shows the Budd and Bodine store on the left, then Ferslew's across the street. On the right, a Mobil station now sits where Texaco was in the previous picture, then Andersen's restaurants. Service stations brands and locations changed frequently along the highway as oil companies merged, developed, and competed for business.

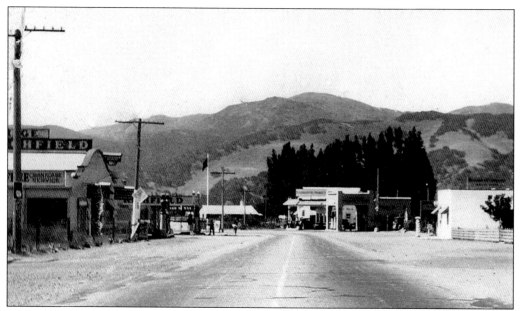

Buellton was a service town full of stations. Practically every major, and many minor, brands of gasoline were represented in Buellton along the Coast Highway over the decades. Some brands even held down two locations to catch traffic going north and south.

Changes of ownership or management were also frequent in the service station business. With the number of stations in town, competition could be fierce, especially in the winter months when travel business slowed down. Often, as the operators changed, so did the brand of gasoline, making it hard to track who held down which locations when.

Announcement . . .

HAVING LEASED THE BODINE SERVICE GARAGE IN BU-ELLTON FROM L. R. THOMSEN, WE WISH TO ANNOUNCE THAT BOTH THE GARAGE AND SERVICE STATION WILL BE OPEN FOR BUSINESS TODAY, AND INVITE YOUR PATRON-AGE.

Service Station

Super Service
Unit

Richfield

OPERATOR

Norman FitzGerald

GARAGE

Complete Mechanical
Service

■

Ken Prentice

PHONE 3461

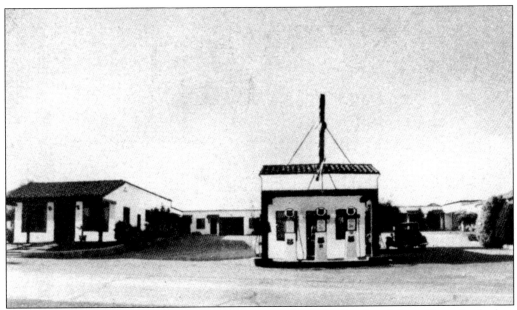

Even the motor courts offered gasoline. This picture shows the Buellton Motor Court in the late 1930s or early 1940s offering Phillips 66 gasoline from a small service station in the middle of the motel.

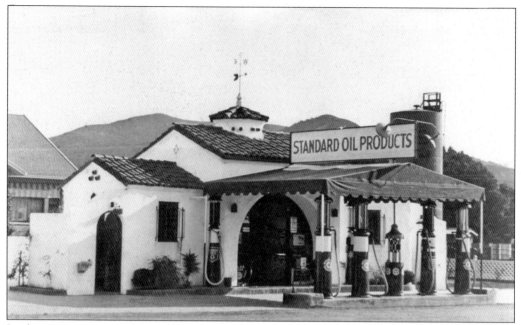

In the 1920s, Oliver and Emma Skinner of Lompoc bought the Buellton Service Station. The property included the station, a house behind it, and a garage building and another service station next door. They became a dealer for Standard Oil products and began making improvements to one of Buellton's earliest service stations.

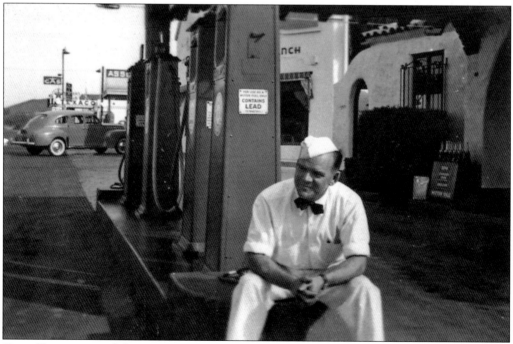

Gene Skinner, son of the owners, mans the pumps on a slow day at the service station. Behind him, modern clock-face gas pumps have replaced earlier pumps seen in the previous photograph.

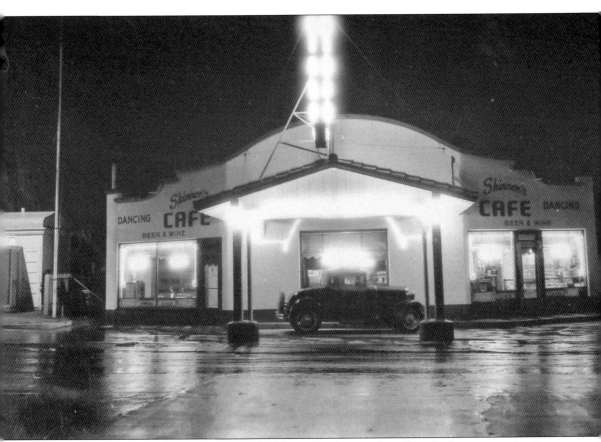

The Skinners converted the old garage building next door to their Standard service station into a dining room and dance hall in the mid-1930s. Their dance hall featured bright neon signs and became a popular spot for the locals that liked to dance the night away.

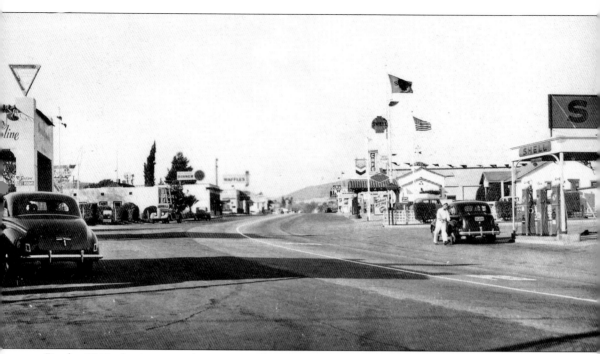

By the 1940s, business was booming in the service town of Buellton. Rows of service stations, motor courts, and diners lined both sides of Highway 101, as happy service station attendants in snappy uniforms waited to attend to the travelers. Bright neon signs were a beacon to the weary nighttime traveler, welcoming them to Buellton and the service town on the Coast Highway. This view is from the south end of town, looking north on the highway.

Motor courts, such as Axel Brus's Sun Valley Auto Court, were popular for overnight lodging in the 1930s and 1940s. Small cabin-like rooms with attached garages offered weary travelers a place to park for the night as they journeyed up and down the coast.

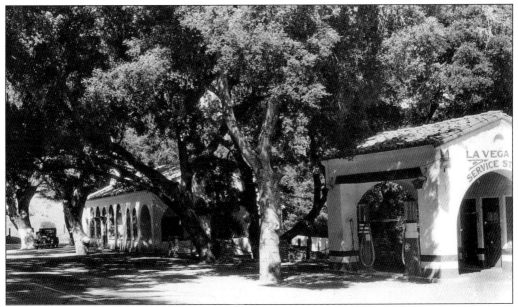

Just before entering Buellton from the south, two local entrepreneurs built a fine restaurant and service station amidst a grove of beautiful oak trees. The La Vega Park and Café opened in October 1929, just before a stock market crash on the East Coast changed the outlook for the entire country throughout the 1930s.

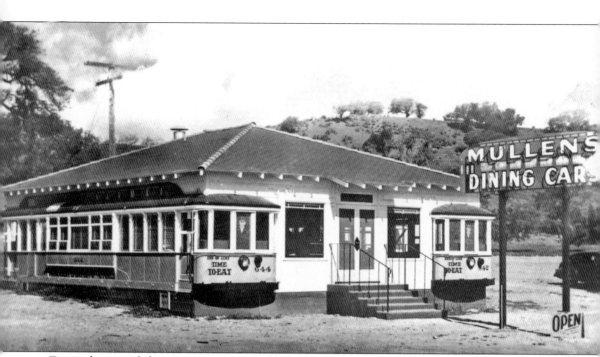

Certainly one of the more innovative ideas to arrive in Buellton, Ed Mullen's Dining Cars Café pulled into their permanent station just north of Buellton in 1946. Unfortunately, this somewhat out-of-the-way location, along with some major changes to the configuration of the highway, made it difficult for this unique business to survive. Mullen gave up his idea after just three and a half years, leasing the dining cars to a succession of operators until no one would try it anymore.

Four

PEA SOUP POTENTIAL

When the Coast Highway was paved through town in 1922, it put Buellton on the map. This event was significant to the founding of the town, but a good argument can be made that the town was actually built upon a solid foundation of split pea soup. As foundations go, pea soup probably would not be the first choice, but in Buellton, it was solid enough to outlast a major paved highway.

The Andersen's pea soup story begins in Buellton in 1924, but actually there wasn't any pea soup involved. At least not in the very beginning.

Anton and Juliette Andersen, along with their young son Robert, moved to Buellton in 1924 intent on opening a small café. Anton was a classically trained chef with experience at the Biltmore Hotels in New York and Los Angeles. His French wife, Juliette, was also an outstanding cook. Anton's brother, who lived nearby in the recently established Danish colony of Solvang, drew them to the newly developed town of Buellton.

One of the benefits of a major highway running through town was the introduction of electricity. Power lines ran along the easement of the highway allowing the town of Buellton to be electrified. The Andersens took advantage of this newly introduced utility and opened Andersen's Electrical Café on June 13, 1924. It was so named because of the modern electric appliances used to run the restaurant. A simple sign on the building proclaimed "EATS." Pea soup was not one of the initial offerings on the menu.

It did not take long for the Andersens to establish a loyal following in Buellton. Both the food and the service were excellent. Truckers and traveling salesman spread the word up and down the coast of California. Soon people were stopping in to find out what the Andersen's Electrical Café was all about.

In 1924, Anton, Robert, and Juliette pose in front of their new diner shortly after opening. Who knew that this little diner would become a pea-soup empire and Buellton's longest-lasting business?

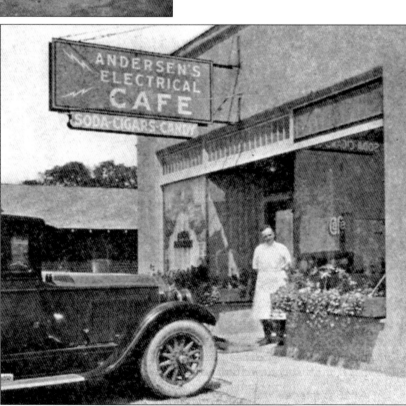

Anton poses at the entrance of the new café sporting the Andersen's Electrical Café sign, installed shortly after it opened. The Andersen's modern, all-electric kitchen was the talk of the town.

The all-electric range was the centerpiece of the electric kitchen. Electricity was relatively new to Buellton, having arrived with the highway after 1917. The Andersens took advantage of this new utility in their modern café kitchen.

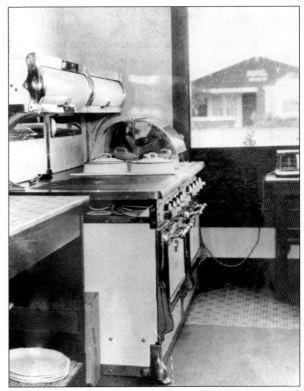

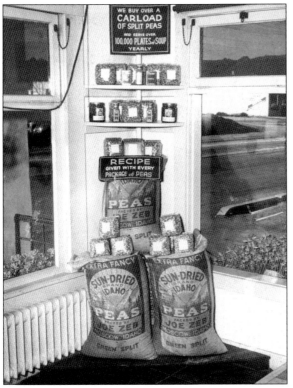

One day, Juliette decided to offer her mother's recipe for split pea soup as a special, and it soon made history. The flavorful soup, with bits of ham, became an almost instant success. The demand for soup was so great that they had to stack the sacks of surplus peas in the window of the restaurant. The sacks of peas were also great advertising.

61

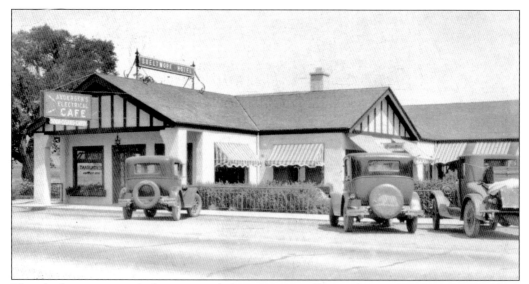

The Andersens opened their original diner in a small storefront in 1924. By 1928, their success allowed them to make a significant expansion. A new restaurant building and hotel were constructed along Highway 101. This early image of the restaurant shows the Andersen's Electrical Café sign over the door and a Bueltmore Hotel banner on the roof.

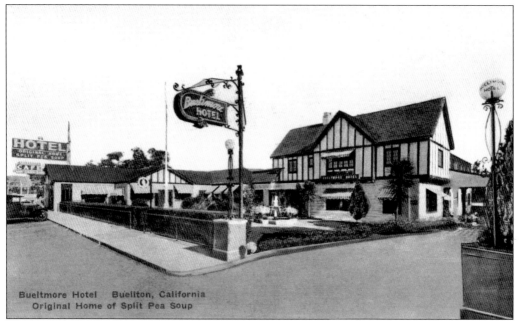

The Bueltmore Hotel was named in joking deference to Anton's days at the ritzier Biltmore Hotels in New York and Los Angeles. The Andersen's hotel consisted of 16 rooms in a two-story building, with a fountain and courtyard in the front. Arriving guests drove through a portico on the side and their cars were parked in private garages at the back of the property.

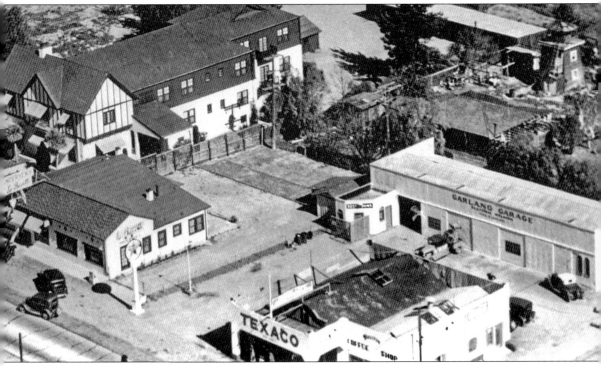

This aerial image shows the side of the Bueltmore Hotel. Just to the right, the Andersens opened another restaurant in the 1930s called La Buvette, where they showcased Juliette's fine French cuisine. For many years, a Texaco service station stood next door, and behind it was the original location of Garland Garage.

In 1931, the Andersens found themselves waging a pea-soup war with their next-door neighbor Max Ferslew. Ferslew erected signs on his building advertising his pea soup in competition with the Andersen's successful venture. Confused travelers were not sure which restaurant was the home of the original split pea soup, for which the town was now well known.

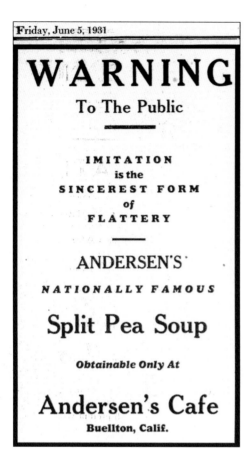

The pea-soup war degenerated into lawsuits. Ferslew sued Anton Andersen because Andersen erected a 16-foot fence along his property line to block Ferslew's signs from the road. Andersen sued Ferslew to force him to take down his offending signs. In the end, both parties won and lost as Andersen had to take down the fence, and Ferslew had to cover his signs.

SPLIT PEA SOUP IN COURT ONCE AGAIN

Buellton, which is known the world over for "split pea soup," received some more publicity Monday.

Max Ferslew, proprietor of the Rainbow Cafe appeared before Superior Judge Atwell Westwick in Santa Barbara, and was fined $50 for contempt of court, for failing to carry out the court's order in removing the certain light esulpment, and desist advertising his split pea soup and place of business in such a way as to lead the public to believe that his restaurant is the one operated by Antone Andersen.

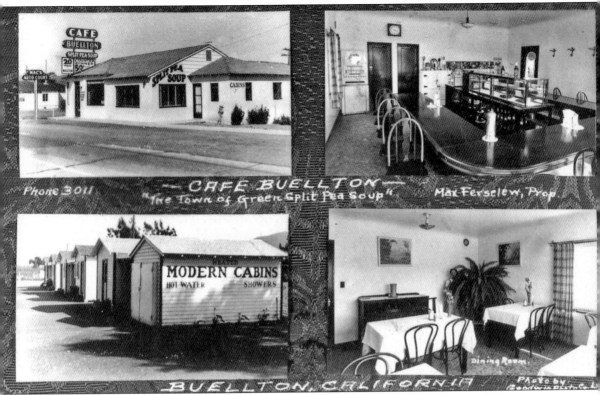

This postcard shows the offending signs on Max Ferslew's restaurant in the upper left corner. The Andersens were probably also offended by Ferslew's card advertising "The Town of Green Split Pea Soup." The Andersens ultimately prevailed and outlasted Ferslew's attempt to steal their business.

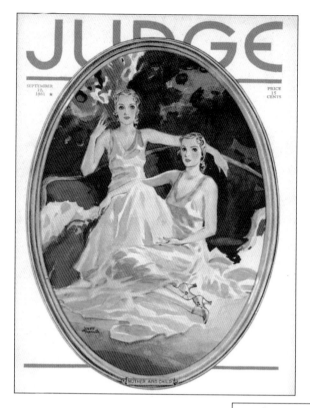

This September 1931 issue of *Judge* magazine was home to the cartoon that started it all. Ironically the cartoon was published the same year that Anton was fighting with Ferslew, and it would provide a solution to any future problems with identifying who had the real pea soup. A cartoon would become Andersen's icon along the Coast Highway and eventually all over the world.

The cartoon was just one of a series of "Little Known Occupations" drawn for *Judge* magazine by artist Charles Forbell. Of course, it was only the occupation that mattered to the Andersens, and they quickly obtained permission to use it in advertising their little restaurant in Buellton.

LITTLE KNOWN OCCUPATIONS
Splitting Peas for Split Pea Soup

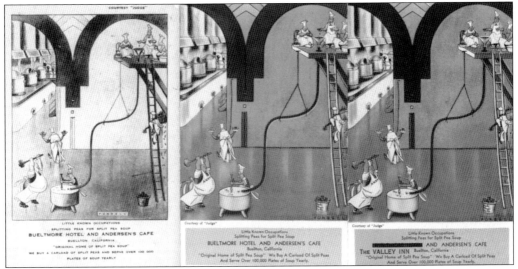

One of the first applications of the pea splitters to advertise Andersen's was a postcard featuring the cartoon. Cards advertised the restaurant and hotel as it went through various changes over the years. The pea-soup-splitting characters became traveling ambassadors for Andersen's, courtesy of the U.S. Postal Service and the many travelers that mailed the cards to their friends and relatives all over the world.

POST CARD

Recipe for 8 Bowls of
Andersen's Famous Split Pea Soup

 2 QTS. OF SOFT WATER
 2 CUPS OF PEAS
 4 BRANCHES OF CELERY
 2 CARROTS—1 ONION
 ¼ TEASPOON OF THYME
 1 PINCH OF CAYENNE
 1 BAYLEAF—SALT—PEPPER

Boil hard for 20 minutes -- then

slowly until peas are done.

Strain through colander.

Compliments of
ANTON ANDERSON (The Pea Soup King)

NEW YORK GRAVURE CORP., NEW YORK CITY

In addition to advertising, the postcard solved another problem for the Andersens, at least early on. On the back, they published their pea soup recipe, which they freely distributed. The card saved them time because they did not have to stop what they were doing to write it down. Of course, this published recipe failed to list one of the key ingredients—the ham!

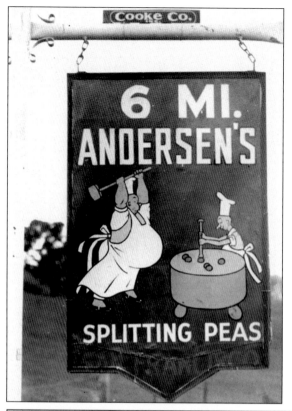

In addition to the postcards, the pea-splitting duo found themselves in another place of prominence. They were painted onto signboards leading the way into Buellton along the Coast Highway. The signs counted down the miles to Andersen's until the travelers arrived at the real home of the split pea soup, where a sign featuring the duo hung over the door. From then on, there would be no mistaking the real Andersen's from the imitators.

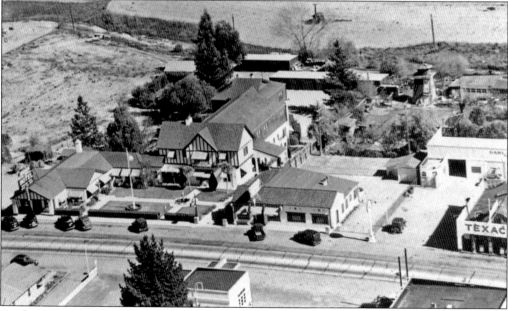

As the 1930s came to a close, the Andersens' little diner had grown to a place of prominence in Buellton. The complex now consisted of two restaurants and the Bueltmore Hotel. In the meantime, young Robert had gone off to school at Stanford University and would soon come back to the family business with some big ideas for the future.

Robert "Pea Soup" Andersen grew up in the family business. He came to Buellton with his family when he was 12 years old and saw the Andersen's empire grow. In the mid-1930s, he went to Stanford University and then took some time to travel with his mother, Juliette. By 1940, he was ready to settle into the family business and soon began implementing changes to position Andersen's for the future.

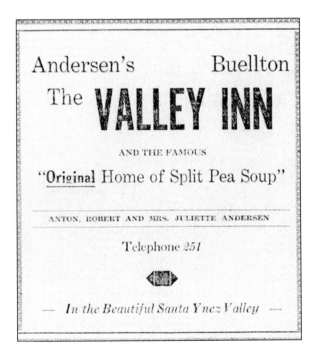

Andersen's Buellton

The **VALLEY INN**

AND THE FAMOUS

"Original Home of Split Pea Soup"

ANTON, ROBERT AND MRS. JULIETTE ANDERSEN

Telephone 251

— In the Beautiful Santa Ynez Valley —

One of the first changes was the name of the Andersen's complex. Instead of the Bueltmore Hotel, it would now be known as The Valley Inn, and the Original Home of Split Pea Soup became a phrase that would be trademarked to Andersen's. Robert didn't give any reasons for the name change, he just ran a simple ad in the local newspaper and had the signs changed.

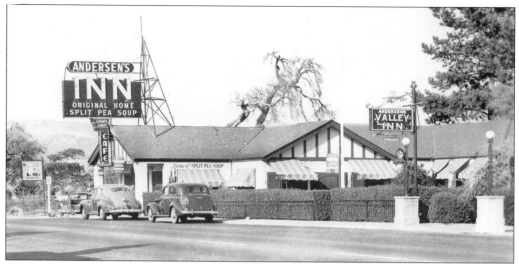

The new sign over the restaurant would make it clear that Andersen's was the "original home of split pea soup." Note that the pea-splitting duo were also displayed on a smaller sign in front of the restaurant, right on the highway.

The inside of the café was not particularly large, featuring a horseshoe-shaped bar around a central serving area. As tourism along the Coast Highway expanded and the Andersen's restaurant became more popular, Robert and the Andersens would have to solve this space problem to accommodate the crowds.

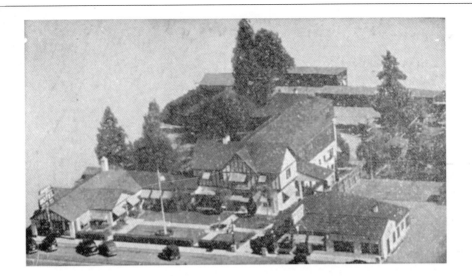

ANDERSEN'S ～ BUELLTON
The VALLEY INN
All Rooms Combination Shower-Tub
WINE CELLARS
Free Private Garage

And the Famous

Original HOME of SPLIT PEA SOUP

WE BUY A CARLOAD OF SPLIT PEAS and SERVE
OVER 100,000 PLATES OF SOUP YEARLY

❖

. . . ANTON, ROBERT and MRS. JULIETTE ANDERSEN . . .

As the 1940s dawned, the Andersen's Valley Inn was in full swing. Robert would commission another makeover just before the interruption of World War II. However, this makeover did not have anything to do with the buildings or the name of the business.

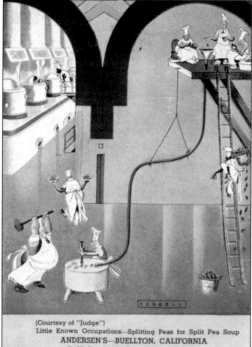

(Courtesy of "Judge")
Little Known Occupations—Splitting Peas for Split Pea Soup
ANDERSEN'S—BUELLTON, CALIFORNIA
THE VALLEY INN
and the Famous
"Original Home of Split Pea Soup"
We Buy a Carload of Split Peas and
Serve Over 100,000 Plates of Soup Yearly

When the name changed to The Valley Inn, the postcard changed too. Initially it was just the information on the bottom, but Robert had another change in mind. He asked a Disney animator named Milt Neil to look at a makeover for the pea-splitting duo featured on the card.

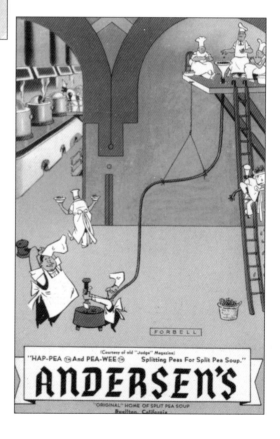

(Courtesy of old "Judge" Magazine)
"HAP-PEA ™ And PEA-WEE ™ Splitting Peas For Split Pea Soup."
ANDERSEN'S
"ORIGINAL" HOME OF SPLIT PEA SOUP
Buellton, California

Neil's changes were relatively simple. He brought a friendlier "Disney-esque" look to the two main characters and left the rest of the cartoon alone. Although Neil would become better known for another character he created, Howdy Doody, these two pea splitters would have worldwide appeal as they became more prominently featured as Andersen's ambassadors.

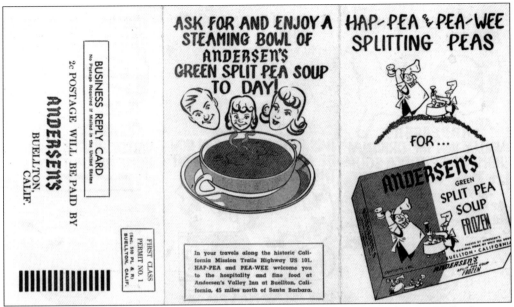

World War II put Robert Andersen's plans on hold temporarily, as the Andersen's Valley Inn was used to house and feed officers during the war. The Andersens also bought the property across the street to provide additional space to feed troops. When the war ended, this space would be used to launch one of Robert's first ventures to bring Andersen's Pea Soup to the entire country and perhaps the world—frozen soup.

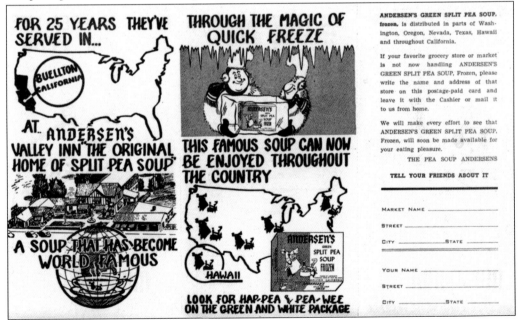

Another event occurred at Andersen's after World War II related to the new cartoon. A contest was held to name the characters in the pea-splitting duo. Occasionally the name "Andy" appeared on the apron of the early versions of the big character, but this was for Anton "Andy" Andersen and wasn't really the character's name. The outcome of the contest was "Hap-pea" for the big guy and "Pea-wee" for the little one, as advertised on this frozen soup promotional card.

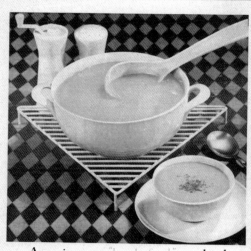

Amazing new "kettle fresh" method
brings you better flavor than __frozen__ soup!

It's sheer "taste magic" ... the wonderful new discovery that seals in all
the deliciousness of Andersen's Split Pea Soup! No other process, nor
even the fastest freezing, locks true taste in so quickly—so completely!
Every delicate accent of flavor that you would enjoy at Andersen's
famous Pea Soup Restaurant is transported right to your own table.
It's cooked in small batches, artfully seasoned to matchless richness.
Try "Kettle Fresh" soup. Let your family enjoy the delicious difference!

ANDERSEN'S FOODS, INC.
Santa Barbara, Calif.

ANDERSEN'S
SPLIT PEA SOUP

The frozen pea soup was a good idea for
franchising the now-famous pea soup, but
it never really worked out. The soup did
not taste like the original and never really
froze right. Robert turned his attention to
canning the soup instead. This proved to be
a better idea, and Andersen's Kettle Fresh
Soup was soon being advertised in national
magazines and sold in supermarkets.

As the idea caught on, more flavors were
added in addition to the split pea soup.
Soon a variety of flavors were being offered
and prominently promoted, as this menu
insert from Andersen's restaurant attests.

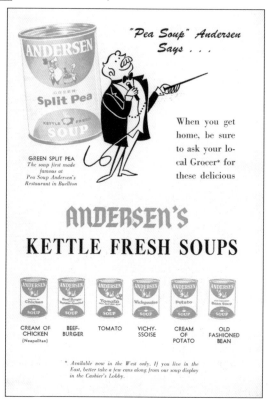

"Pea Soup" Andersen
Says . . .

ANDERSEN
Split Pea
KETTLE FRESH
SOUP

GREEN SPLIT PEA
The soup first made
famous at
Pea Soup Andersen's
Restaurant in Buellton

When you get
home, be sure
to ask your lo-
cal Grocer* for
these delicious

ANDERSEN'S
KETTLE FRESH SOUPS

| CREAM OF CHICKEN (Neapolitan) | BEEF-BURGER | TOMATO | VICHY-SSOISE | CREAM OF POTATO | OLD FASHIONED BEAN |

* Available now in the West only. If you live in the
East, better take a few cans along from our soup display
in the Cashier's Lobby.

Robert even appeared in television advertisements with his pea-splitting duo, Hap-pea and Pea-wee, to sell the soup. While the canned soup was more of a technical success than the frozen soup, it was only a modest financial gain. The investment in the infrastructure to produce it had taxed the Andersens and would lead to the sale of the soup label to an outside interest, where it would be produced for years.

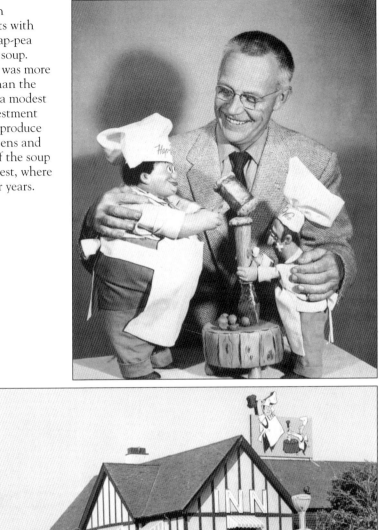

Starting in 1948, some significant changes occurred to the Coast Highway through Buellton. An explosion in postwar travel demanded that the highway be widened through the middle of the service town. Widening the highway meant that Andersen's restaurant had to be moved. It also put the road right in front of the old Bueltmore building, taking away the courtyard and fountain. Robert used this opportunity to expand the restaurant, converting the downstairs of the hotel to dining and gift shops and connecting the old restaurant building.

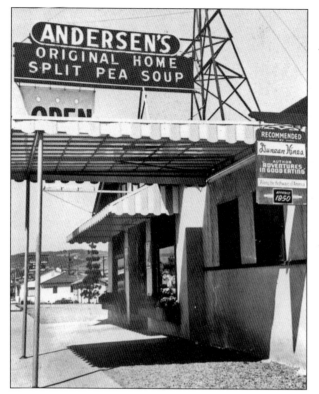

Even though the restaurant was moved, the entrance changed very little. The sign above it had changed several times, starting out as Andersen's Electrical Café, then Andersen's Inn, and finally Andersen's, as pictured here. It would remain this way until after an ownership change in 1965.

Robert's wife, Rosemary, started the gift ship in the 1950s. It would become a permanent fixture at Andersen's, offering Hap-pea and Pea-wee merchandise, along with many other gifts, as described in this article from the Andersen's monthly employee newsletter called *The Dispatch*.

The sight of gay new merchandise heralds the first glimmerings of Spring in the Gift Shop. Our tour of the Gift Show was, as always, exciting and we brought back many "all-new" items and many "old," but with "new design," favorites!

Our spring and summer glassware has come in and it is beautiful—the new designs and colors are every bit as exciting as the names—Aloha Orange, Aloha Turquoise, Rondo Blue, Prado Green, Cellini Leaf, Valencia, Florentine, Tyrol Platinum, etc.—all of these, in sets of eight, priced from $6.50 the set—in either Hiballs or Double Old Fashioned glasses. We were delighted to find the ever-popular jeweled Mardi Gras design back in the line.

Vera, the "gay-heart," has gone all-out in her spring collection of kitchen towels and pot holders to match—tulips, roses, daffodils in wild, wonderful colors to give that face uplift to any kitchen.

We are really saving all of our "goodies" until March 1st. Inventory is the 29th of February, so almost all of our January ordering does not arrive until after the zero hour. However, an early delivery of beverage napkins and coasters have been put out and they are wonderfully whimsical, colorful and gay.

California artist Howard Pierce has come back this season with his charming porcelain animal figurines—families of cats, geese, quail, ducks, bears, squirrels and owls—the colors are ebony and brown and sell from $3.50 the set.

Easter is early this year so right after March 1st we will be receiving and putting out all of the "temptations" and you just wait and see how hard it will be to resist all of the pretties.

ROSEMARY ANDERSEN
Gift Shop Manager

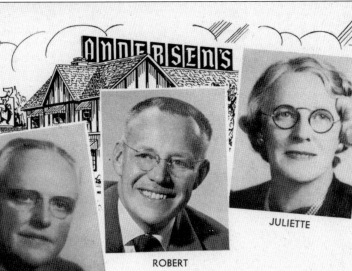

ANTON

ROBERT

JULIETTE

ROSEMARY

ROBBY

THE ANDERSENS

"Pea Soup" ANDERSEN'S Restaurant dates back to June, 1924, when Anton and Juliette Andersen arrived in California's beautiful Santa Ynez Valley and opened their highway restaurant in Buellton. Proud of their modern equipment, they named the eating place "Andersen's Electrical Cafe". Anton was from Denmark and Juliette from France, both with years of experience in the preparation of fine foods. Juliette's recipe for Split Pea Soup was an immediate favorite, and with Anton's flair for the dramatic, they soon popularized the restaurant as "The Original Home Of Split Pea Soup".

Now ANDERSEN'S is a world famous stop for travelers, not only for delicious split pea soup, but also for fine, wholesome food served in unique surroundings. Continuing the Andersen tradition is Robert T. "Pea Soup" Andersen, son of Anton and Juliette, who has enlarged and modernized the restaurant. Working with him in the business is his wife, Rosemary, and their son, Robby. Recent additions to the establishment are the authentic Wine Cellar and interesting Gift Shop, featuring imported items from Europe, especially the Scandinavian countries.

To answer the demand for Andersen's Split Pea Soup throughout the country, Robert Andersen found a method of preserving its delicate flavor in a new canning process. Today, this famous Split Pea Soup and a full line of *Kettle Fresh* Soups are made and sold by Andersen Foods Division of Tillie Lewis Foods, Inc., Stockton, California. They all carry the famous Andersen trade-mark of "Hap-Pea" and "Pea-Wee", the two comic chefs, "Splitting Peas for Split Pea Soup".

Robert Andersen had a strong sense of family. This extended beyond his genetic family to all of the employees at Andersen's. He was well liked by the employees and many of them were tremendously loyal to Andersen's restaurant, working there for decades under Robert's leadership.

The Management Wheel - - - - - At ANDERSEN'S

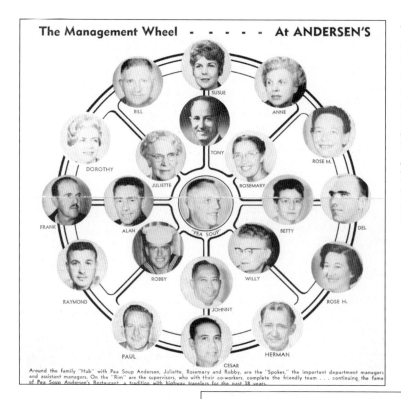

SUSUE

BILL

ANNE

DOROTHY

TONY

ROSE M.

JULIETTE

ROSEMARY

FRANK

ALAN

"PEA SOUP"

BETTY

DEL

ROBBY

WILLY

RAYMOND

ROSE H.

JOHNNY

PAUL

CESAR

HERMAN

Around the family "Hub" with Pea Soup Andersen, Juliette, Rosemary and Robby, are the "Spokes," the important department managers and assistant managers. On the "Rim" are the supervisors, who with their co-workers, complete the friendly team . . . continuing the fame of Pea Soup Andersen's Restaurant, a tradition with highway travelers for the past 38 years.

This sense of family among the coworkers was conveyed in newsletter articles about the employees and rewards for their innovative ideas that could benefit the business. Robert also conceived of his "management wheel," which shows many of the long-term employees.

Perhaps portending the bright future of the wine industry in the Santa Ynez Valley, Andersen's restaurant operated their own wine cellar under the leadership of Oscar Johnson. Their featured wines were Danish fruit wines offered under the Andersen's own label. In addition to their own wines, there was also an excellent selection of French and Italian wines.

Two Pea Soup Generations

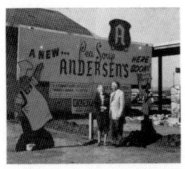

Mrs. Juliette Andersen and Mr. Robert "Pea Soup" Andersen visiting the new restaurant in Santa Maria.

Forty years ago when **Mr. and Mrs. Anton Andersen** opened the doors to the original Pea Soup Restaurant, they could not forsee the outcome of their business and the tremendous success and reputation they would create with their efforts.

Maman Juliette was really moved when she visited last week the almost-completed new Pea Soup Restaurant in Santa Maria, first of a long list of new restaurants all over California. And as **Madame Juliette** said, "There is nothing more important in our life than the good will to achieve something, faith in our future, hard work and trust in our Lord."

There is very little chance that we could find another restaurant in the United States or in all the world which made its way just by creating a delicious pea soup. **Madame Juliette** can be proud, and we all express our heartiest congratulations and our best wishes for many, many more hap-pea years.

In addition to developing food products and expanding the Andersen's restaurant in Buellton, Robert Andersen had big plans for expanding the Andersen's franchise in California. He dreamed of a line of restaurants up and down the coast of California bearing the Andersen's banner. By the mid-1960s, the expansion plans were in high gear, with restaurants under construction and scheduled to open in Santa Maria, 30 miles to the north, and Salinas.

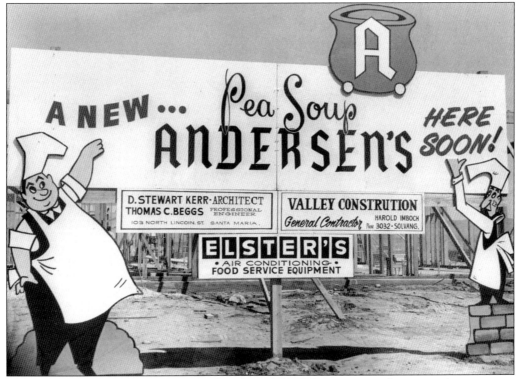

The restaurant in Santa Maria opened in late 1964. Salinas managed to open the next year amidst public fanfare and congratulations. Unfortunately, the early ventures into frozen and canned soup, along with under funded ventures into new locations, left the Andersens overtaxed. The new restaurants would prove to be the undoing of the Andersen family's ownership of their namesake restaurants. Robert was forced to sell the Buellton location, and the Santa Maria and Salinas locations were closed and sold to the Denny's Corporation. After 40 years of family ownership, the Andersens' run at Andersen's was over by the end of 1965.

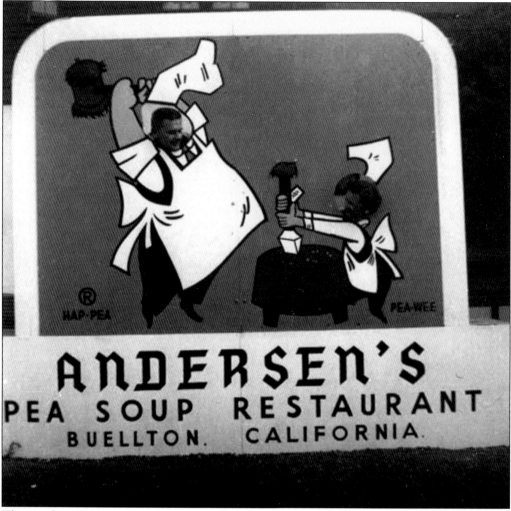

The Andersen family gave their customers plenty to smile about during their 40 years of ownership and management of their business. Even today, those who knew Robert Andersen speak fondly of his paternal management style. It was a sad day when they had to sell their business, but they remained well remembered in the community. The consolation was that a new owner would take the helm of the family business and do the Andersen name proud for many more years.

Five

SERVICE TOWN, U.S.A.

The end of World War II resulted in an explosion of travel in the United States. This was especially true along the coast of California. Young war veterans with military training, experience, and discipline came streaming home to their families and in many cases, young children. These young families were ready for adventure and travel along the open roads.

In the meantime, the California State Highway Department had been looking at ways to speed travel along the Coast Highway before and during the war to meet the need for free-flowing traffic. One of their main considerations was finding ways to get around the service towns and intersections that slowed travel.

Buellton was one of these service towns made up of diners, motor courts, and gas stations. The business owners' livelihoods depended on slowing down the travelers and getting them to stop. When word got out that the town might be bypassed, they banded together to rally against what they knew would be devastating to their trades.

After a great deal of negotiation between the Buellton business and property owners, the Santa Barbara County Board of Supervisors, and the State Highways Department, a unique compromise was reached. This compromise was so unique that it was proposed to be a model for other towns like Buellton that were located on portions of major highways.

The design called for two lanes of free flowing traffic both north and south in the center. On either side of the main freeway lanes there would be outer service lanes traveling both directions to allow access to the businesses on either side of the freeway. There was only one major problem—the businesses were too close to the existing two-lane highway for six additional lanes to be built. For the highway to be widened, buildings would have to be torn down or moved back to allow for 58 feet of additional right-of-way. This would require the consent and cooperation of numerous property and business owners to achieve. They would also have to bear a great deal of the expense.

On March 15, 1948, an agreement was signed and a major rebuilding of Buellton was soon underway.

COUNTY OF SANTA BARBARA

CALIFORNIA

DEPARTMENT OF PLANNING AND PUBLIC WORKS

COURT HOUSE
SANTA BARBARA
CALIFORNIA

April 19, 1948

RICHARD S. WHITEHEAD
DIRECTOR

WALLACE C. PENFIELD
CONSULTANT

Honorable Board of Supervisors
County of Santa Barbara
Court House
Santa Barbara, California

Gentlemen:

At the request of the Board of Supervisors, the Department of Planning and Public Works submitted in October 1947, an application for an allotment of funds under Chapter 20, Statutes of 1946, for the construction of side roads through the Town of Buellton.

Under this application, the State was to provide $15,000 out of the "Roads Only" fund and the County was to provide $15,000 out of the County Good Roads fund derived from the Motor Vehicle Fuel fund. The State money is not taken from the $75,000 free money.

The State has now allocated its $15,000 to this project and the attached letter from the State Division of Highways requests that the County deposit $9,292.70 with the Division of Highways. This will total $24,299.70, the estimated cost of constructing the outer highways. Since the original estimate was $30,000 and the State has put up $15,000, it is recommended that the County freeze $15,000 of Gas Tax Money so that half of the total cost of the project may be paid by the County.

It is further requested that authority be given to the auditor to deposit the $9,292.70 with the Division of Highways.

Yours very truly,

Richard S. Whitehead
Director

RSW:bl
Enc.

Achieving an agreement to avoid bypassing Buellton required cooperation all around. As this letter attempts to explain, everyone involved had to kick in some money to make it work. The property owners and tenants had to do more than that; they had to physically move or tear down their buildings that fronted the Coast Highway to make room for the new lanes.

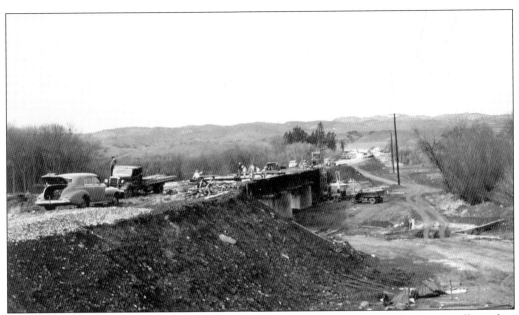

One other reason for the rebuilding of the highway was the original bridge into Buellton that was built in 1917. The steel truss construction had limited overhead clearance, which became a problem as taller trucks and loads arrived on the highway. Serious damage occurred often enough that there were concerns that the bridge could collapse. A new bridge across the Santa Ynez River had to be built.

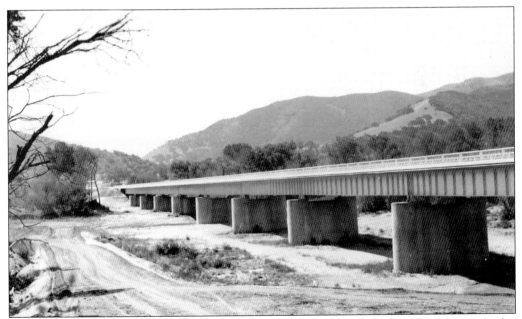

Built in 1948, this concrete bridge replaced the steel truss bridge built in 1917. The new bridge was located to the east of the old one.

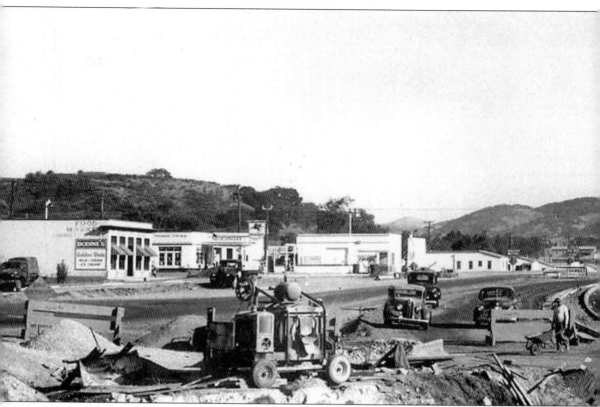

"Road Closed" and "Detour" became familiar signs in 1948–1949 as the construction project progressed through the town of Buellton. This image shows the rough grading on the roadbeds,

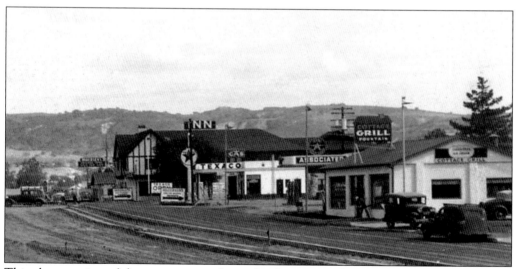

This close-up view of the construction shows the Cottage Grill, right, in the location of what was once Skinner's Café. Today it is Ellen's Pancake House. Service stations sit on both corners of the intersection of Highway 101 and 246, with Andersen's to the north.

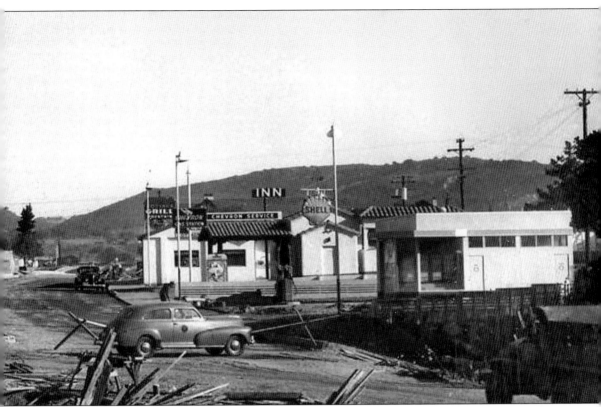

including the service lanes on the east side of the newly widened highway. This view looks north toward the intersection at Highway 246.

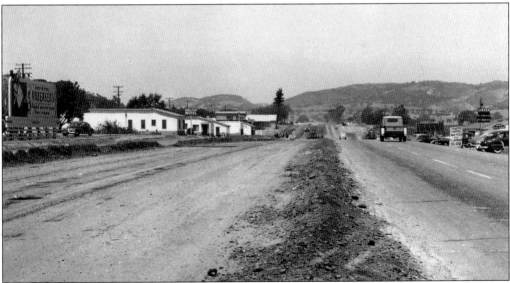

Putting eight lanes of traffic in place of two was a monumental challenge. Buildings were moved and demolished to allow for widening on both sides of the road. This image shows the original Coast Highway lanes on the right, the grading for the two new southbound lanes, and the western service lanes on the left.

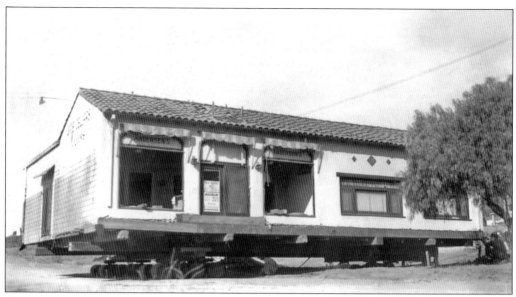

The restaurants at Andersen's were in the way of the new road. By the end of World War II, the Andersens had closed La Buvette, but the building still sat in front of the old Bueltmore Hotel. It had to be lifted and relocated to the back of the Andersens' property.

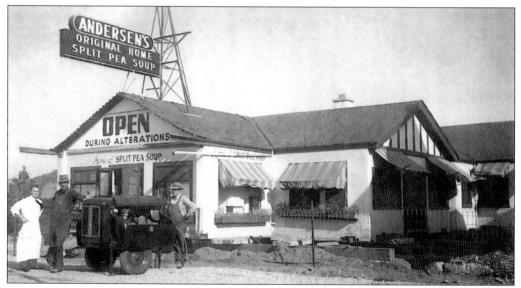

The famous pea soup restaurant also had to be moved while still attempting to stay open and serve soup. The move was made in a day and they managed to keep the restaurant open even in the midst of the construction. The building was moved back in line with the old hotel building. An annex was eventually constructed to connect them. The courtyard of the hotel became the new service lanes on the east side of Highway 101.

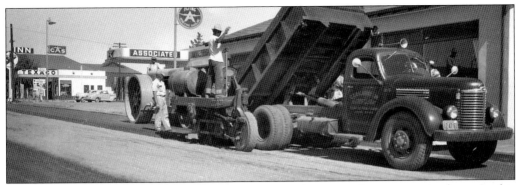

As the work progressed into 1949, the paving operation began on the outer service lanes. In this case, pavement is being laid in front of the Cottage Grill, which many know today as Ellen's Pancake House. Behind the paving truck, a service station sits at each corner of the intersection of Highway 246 and Highway 101.

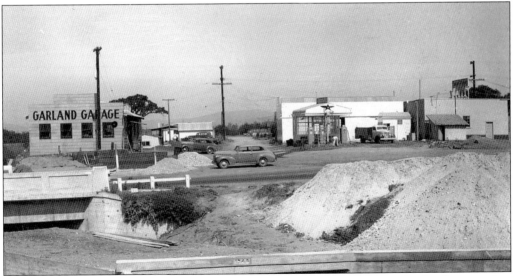

At the south end of Buellton, on the west side of the highway, workers put the finishing touches on a Flying A service station across the street from Garland Garage. Although portions of an older station were torn down to make way for the new road, the Garland Garage still stands today, operating as a muffler shop.

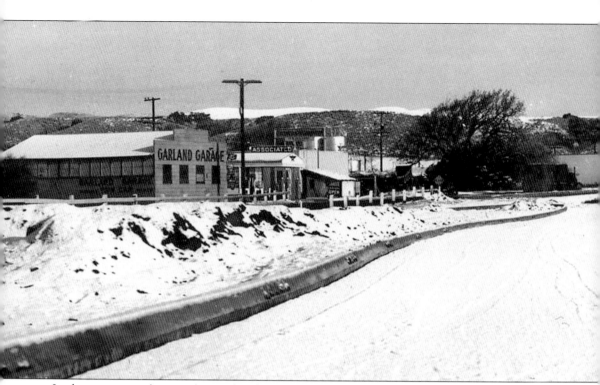

In the temperate climate of coastal California, there were few delays to the construction project in 1948–1949. However, on January 11, 1949, there was one remarkable delay that no one on the central coast of California would have expected—it snowed! An image looking north on

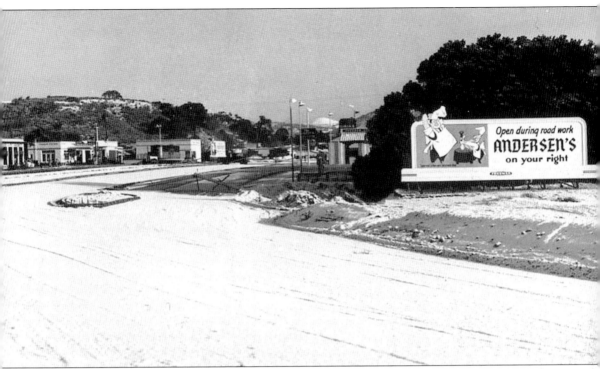

Highway 101 from the south end of town shows just how much snow fell in 1949. It was enough to close the Gaviota Pass and strand many travelers in Buellton for a day or so until the snow melted. Few motorists were prepared for a snowstorm in this part of California.

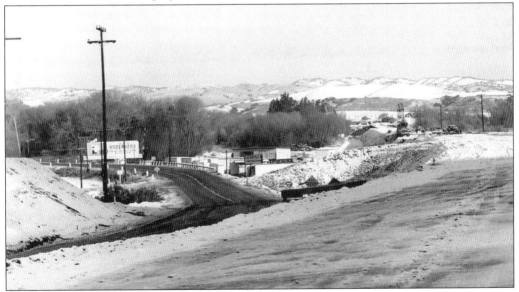

The surrounding hillsides were covered in snow as was the bridge construction leading into town. Most of Ventura, Santa Barbara, and San Luis Obispo Counties were covered in snow by this unlikely storm in 1949. It was enough snow to delight the locals, who were unaccustomed to seeing it this close to home, but not so much that it caused any major delays to the work on the highway.

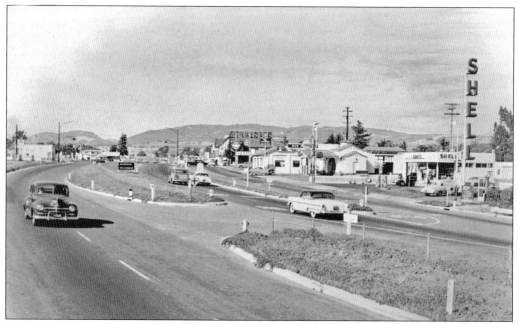

By the end of May 1949, the construction work was pretty well completed. What emerged was a significantly expanded highway and a total makeover for Buellton. The engineers at the California State Highways Department envisioned this design as a model for other service towns and dubbed Buellton "Service Town, U.S.A."

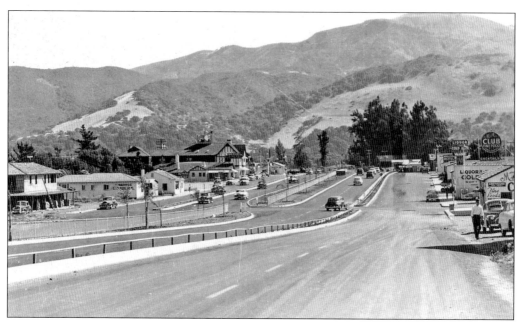

Virtually every building along the old Coast Highway had been remodeled or demolished to make room for the width of the newly designed highway. A number of new motels and service stations were also built. Throughout the 1950s, Service Town, U.S.A. would continue to grow with numerous expansions and additions to the town.

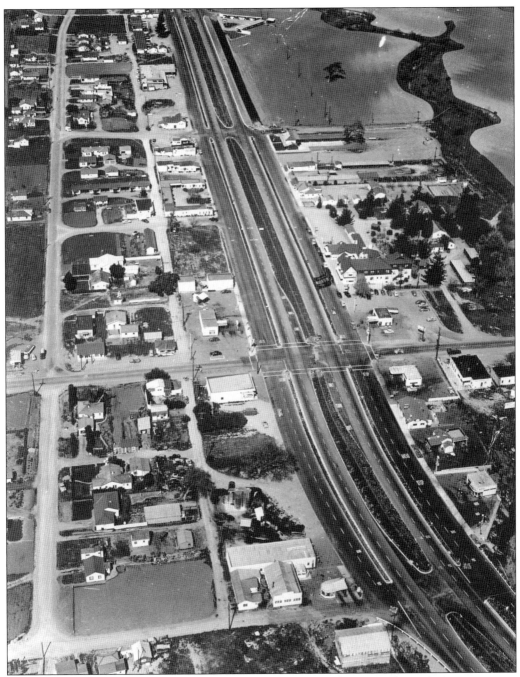

From the air, this view looking north along Highway 101 shows Buellton as a service town in its glory days. An explosion in tourism following World War II would keep the town busy and flourishing as motorists explored the coast of California, and travel increased significantly between Los Angeles and San Francisco.

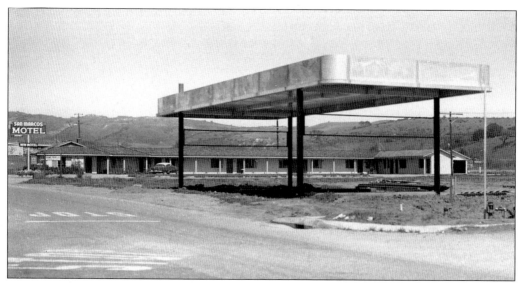

Service stations practically grew out the ground as the major oil companies competed for the tourist trade. Behind this station, the San Marcos Motel was one of several new additions to Buellton, a result of the highway expansion project.

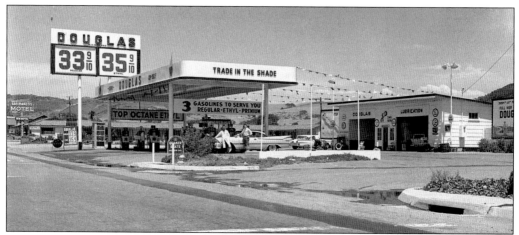

The grand opening of the Douglas service station shows the enterprise in all of its glory. This station originally opened as a Hancock service station, then changed to Douglas, and later became a Lerner-branded station. Shuffling brands was a common occurrence in the service town as major oil companies merged or tried new locations on the highway for more business.

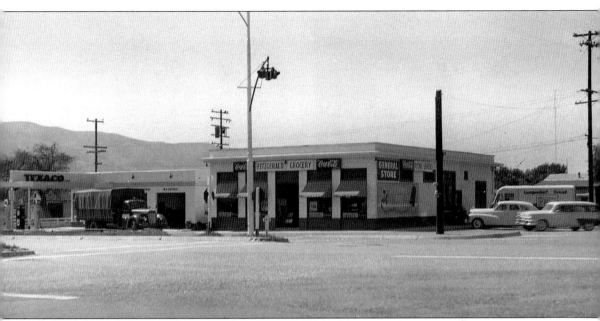

Bill Fitzgerald operated Texaco service stations on two corners of Highways 246 and 101. One caught the northbound traffic in the parking lot of Andersen's, and the other was on the southbound side next to his market, which had replaced the Budd and Bodine store.

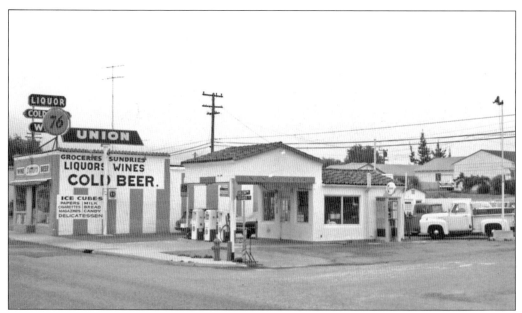

This small Union 76 service station began its life as a Phillips 66 station further south on the highway in front of the Buellton Motel. It had to be relocated as a result of the highway-widening project. The building was moved up the street next to Huston's Liquor store.

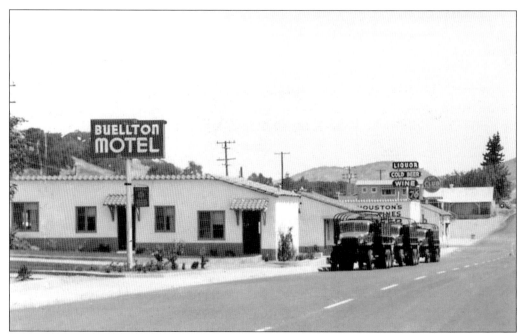

From this perspective, a view along the southbound service lanes shows the Buellton Motel after the road project and the Union 76 sign further down the street under the word "wine" at the liquor store. There was plenty of gasoline and alcohol available for the traveler on this stretch of Highway 101 through Buellton.

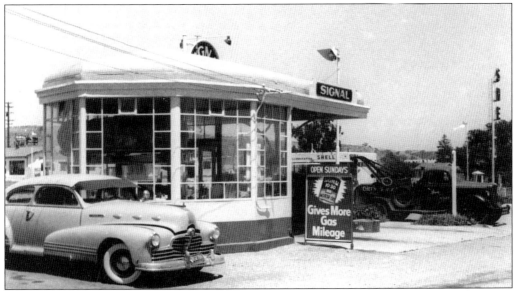

The Chester brothers had a significant influence on the development and change of service stations in Buellton. At one time, each of the three brothers operated a different station in close proximity to one another, including this Signal service station, the Shell across the street, and the Chevron next door to the Shell station.

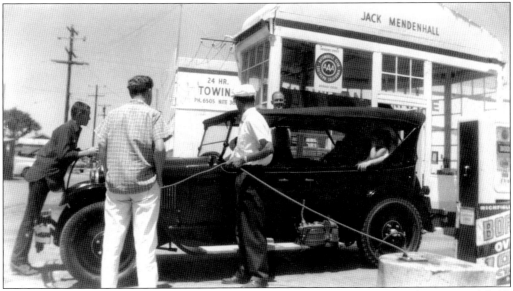

In the late 1950s, Jack Mendenhall bought the Signal station and converted it to a Richfield. Mendenhall had operated a Richfield at the other end of town that he leased from Bill Olivera in the early 1950s.

At the north end of Buellton, a couple of out-of-the-way businesses had appeared before World War II. These businesses were practically out of town and almost entirely dependent on highway travelers from the north. Their out-of-the-way locations would ultimately lead to their demise as the new highway route was laid out east of the old highway, as seen in this construction photograph looking south toward Buellton.

The Constables owned a service station, the El Reno diner, and a small motel tucked into the hillside at the edge of the highway. Business was difficult enough with the highway running right in front of them. Without the highway, it would be nearly impossible to survive. Despite the crying protestations of Mary Constable at numerous civic meetings, they would ultimately be left without travelers to support them when the highway moved.

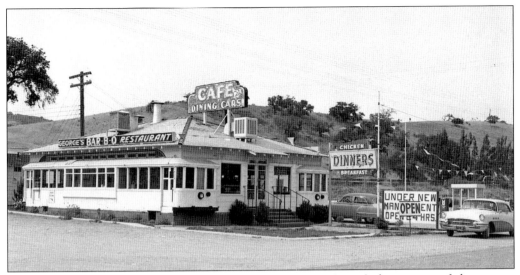

Just to the south of the Constable's complex, the Dining Cars Café was one of the unique additions to Buellton. Despite the novel concept of putting two original dining cars together at the side of the road, the business struggled almost from its beginning in 1946. Numerous operators tried their hand at this out-of-the-way location, but none ultimately succeed.

Some of the locals adopted the dining cars as a drinking hideaway, but the local trade wasn't enough to support a viable restaurant. Even a racetrack located behind the Dining Cars Café in the early 1950s didn't last long enough to bring in business. When the highway moved, it was all but over, leaving the dining cars stranded at the siding for many years to come.

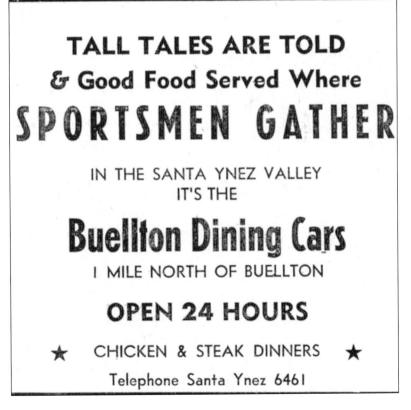

TALL TALES ARE TOLD
& Good Food Served Where

SPORTSMEN GATHER

IN THE SANTA YNEZ VALLEY
IT'S THE

Buellton Dining Cars

I MILE NORTH OF BUELLTON

OPEN 24 HOURS

★ CHICKEN & STEAK DINNERS ★

Telephone Santa Ynez 6461

In addition to supporting a plethora of service stations, motels, and diners, Buellton also supported several towing services. Actually, numerous accidents on the Coast Highway supported the tow truck operators, especially in places like the Gaviota Pass, where winding curves made the road treacherous at times.

Jack Mendenhall operated the AAA towing franchise out of his Richfield service station at the south end of Buellton. Initially the tow operators didn't know just how busy they would be thanks to the new configuration of the highway in Service Town, U.S.A. As it turned out, there would be plenty of wrecked cars to keep the tow trucks busy.

Despite this relaxed pose, Tommy Garland managed to stay busy keeping up his end of the towing business across the street from Mendenhall's Richfield. Garland, a longtime Buellton resident, was married to Kathryn Lauritzen Garland, whose family had hosted the celebration of the paving of the Coast Highway on their ranch in 1922.

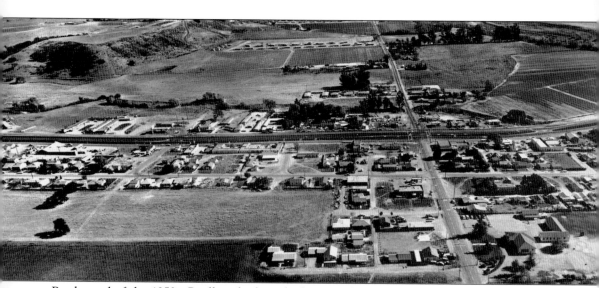

By the end of the 1950s, Buellton had reached its zenith as a service town. This aerial image gives a glimpse of the booming service town in 1959. Highway 101 runs from left to right in the center of the picture, with Highway 246 running top to bottom on the right. Although they didn't know it at the time, things were going to change significantly for Service Town, U.S.A. as the 1960s dawned. In fact, the end of the service town was in sight.

Six

BYPASS SURGERY

In May 1949, the town of Buellton was celebrating a new era of progress and promise. The widening and new configuration of Highway 101 running through the center of town had just been completed.

J. F. Powell was the District 5 right-of-way agent for the California Highways and Public Works Department at the time. He related the story of this new outer highway design after the completion of the highway in 1949. His words tell the story well. "A few short years ago, Buellton, California, as one businessman there described it, was a "small crossroads, under-developed, traffic-bottlenecking, village with a highly uncertain future as a highway town. Today, through recent completion of the Buellton Freeway and its integrated system of parallel outer highways, this former "village" is an outstanding example of an outer highway community known as a service town, and its economic future, dependant on highway business, is assured for many years to come."

While the configuration of the highway did bring about an economic boom in Buellton through the 1950s, it also brought about an unintended consequence. The intersection of the two major highways turned out to be a traffic disaster. Service station attendants on the corners of the intersections devised a game of speculation about who would make it through the treacherous crossing and often came to assist the victims when they didn't.

Crossing eight lanes of traffic on the east-west highway that crossed Highway 101 was more than most motorists could manage. With traffic constantly changing directions through the crossing, drivers couldn't figure out when to stop or start, causing collisions with disastrous consequences. Other accidents happened when drivers braked suddenly to try to enter the service lanes for gasoline, food, and lodging.

As brilliant as the plan may have looked on paper, the new highway configuration caused more accidents and it ultimately brought about the end of Buellton as Service Town, U.S.A. As 1960 opened a new decade, the old plans for bypassing Buellton were pulled out of the archives with a renewed sense of purpose. The State Highway Department was now intent on moving the highway out of the center of town and leaving the services stranded without a road to bring in the business.

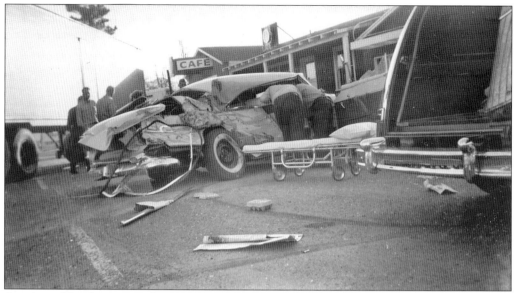

Accidents like this one in front of the Horseshoe Café caused the California State Highways Department to take another look at the configuration of Highway 101 through Buellton and the parallel service lanes. Injury accidents were becoming too numerous to ignore as tourist traffic increased significantly on the Coast Highway through the 1950s.

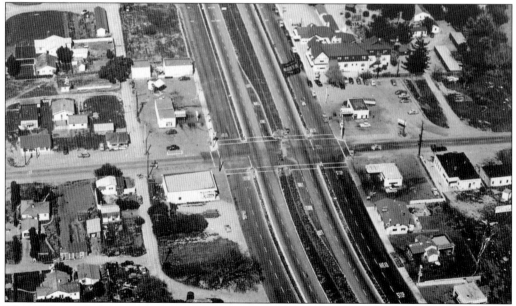

This 1959 aerial photograph shows the intersection of Highway 246 as it crossed the eight lanes of traffic making up Highway 101 with its outer service lanes. Andersen's restaurant can be seen in the upper right corner. It was primarily the treachery of crossing this intersection that would bring about the bypassing of Buellton and the end of the service town that was established in 1917.

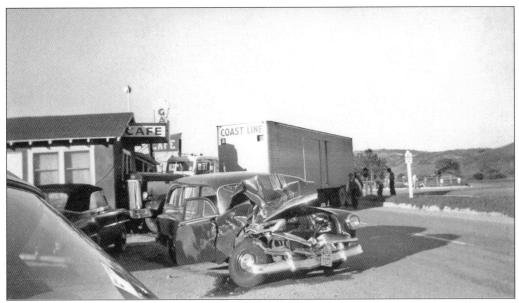

This semi truck almost created Buellton's first drive-through restaurant, barely skidding to a halt at the front door of the Horseshoe Café. The station wagon in the foreground and the car on the other side of the truck suffered most of the damage as the truck driver swerved to avoid the accident. Accidents like this brought about the bypass of Buellton, leaving the service town without a highway to service.

Tom Garland hooks up to yet another car involved in an accident. Highway 101 kept several tow companies busy cleaning up the wrecks from the highway. In addition to the intersection in Buellton, the Gaviota Pass and its winding lanes was a frequent site of accidents.

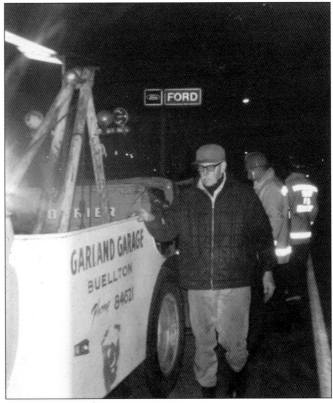

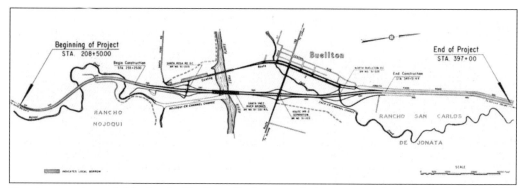

Despite a persistent lobby by the Buellton Businessmen's Association throughout the late 1950s and early 1960s, the bypass became inevitable. The business owners tried their best to put a happy face on the situation, but they knew that the change could only be bad for business. The new route completely bypassed the town to the east with an overpass at Highway 246.

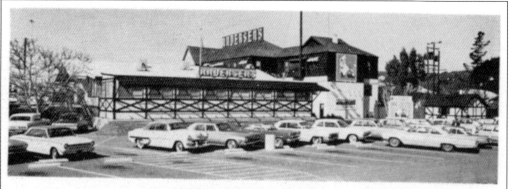

NEW VIEW AT BUELLTON

With the opening of the Buellton freeway by-pass, as we mentioned in our cover picture story, we have a new look to our guest entrance. In the first place, you can now see the ANDERSEN sign prominently as you approach from either north or south on the freeway. Take the Lompoc-Solvang turnoff and as you come up onto the overpass you will see, to the west just beyond the Union Oil service station, this view of our parking lot. During the next few weeks we shall be doing some more landscaping, but even now we think that you will like the things that we have done, under **Paul Kuelgen's** direction, to the Pea Soupery (where **Rotary** meets each Wednesday noon) and some of our service buildings. Those of you who remember the old intersection of Highway 101 and the Lompoc-Solvang road will appreciate the new safety and convenience that has been built into the overpass. All of us in Buellton think that it is a big improvement which took the combined efforts of the Buellton community and the highway department to arrive at a workable arrangement.

Robert "Pea Soup" Andersen was in the thick of the negotiations with the State Highway Department, initially opposing the bypass and then conceding the inevitable and supporting the plan. Andersen's had a great deal at stake, having lasted along the Coast Highway since 1924. Few knew at the time just how much Andersen's had at stake; they were on the verge of losing their namesake business.

The freeway through Buellton is now open and the symbolic ribbon was cut by three longtime Buellton residents. Representing the most famous business in town were **Robert "Pea Soup" Andersen** and his mother, **Mrs. Anton (Juliette) Andersen**.

With them in our picture is another well known resident of Buellton, **Mr. Tom Parks. Tom** is a rancher and local business man. He has served his county well in many public activities such as the County Grand Jury, the area Planning Committee, and as president of the Buellton Businessmen's Association. In the days when U.S. No. 101 was a two lane road through town, **Tom** had the only vegetable packing plant in Buellton, now a depot for a trucking concern.

The opening of the freeway has done two things. It has gotten rid of a very awkward and dangerous main traffic intersection and it also has made access to ANDERSEN'S-BUELLTON a whole lot easier.

It is truly progress.

Robert and his mother, Juliette, were all smiles cutting the ribbon to open the new freeway. As it turned out, the smiles were only masking the pain of losing the family business, which transferred to a new owner shortly after the opening of the highway in 1965. The Andersens were out, and their namesake restaurant was no longer on the Coast Highway, leaving the famous pea soup business in a predicament.

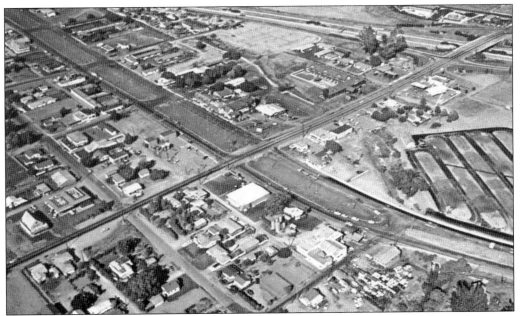

From above, Buellton, after the bypass, features the old highway lanes grassed over leaving a park like strip through the center of town. What does a town do about a four-lane strip of grass through its center? Have a celebration!

THE HONORABLE RONALD REAGAN

AND

THE HONORABLE W. DON MACGILLIVRAY

invite you to spend

A DAY WITH THE GOVERNOR

ON SATURDAY, SEPTEMBER 28

COCKTILS 1:30 - LUNCHEON 2:30 P.M.
Andersen's, Buellton

3:30 Buellton
Avenue of Flags
PARADE AND DEDICATION

4:00 - 5:30
Solvang
RECEPTION

Local gentleman rancher and new owner of Andersen's Pea Soup, Vincent Evans convinced his friend and governor of California to preside over a dedication ceremony of the newly dubbed "Avenue of the Flags" in 1968. For the town of Buellton, it was a small consolation prize for being bypassed by the new freeway.

Local schoolchildren and Boy Scout's brought flags aplenty to the dedication ceremony. Patriotic songs were sung, speeches were given, and in the end, the town did its best to celebrate a difficult situation. Ultimately affected by the new route, many business struggled to survive and most of the service stations closed and moved to locations closer to the off ramps of the new highway if they could.

While the sale of Andersen's wasn't a result of the bypassing of the town, it brought a new owner just in time to make the best of a difficult situation. Vincent Evans brought dynamic leadership and business savvy to Buellton just when it needed it most. He also brought strong political connections, including his close friend Ronald Reagan, governor of California.

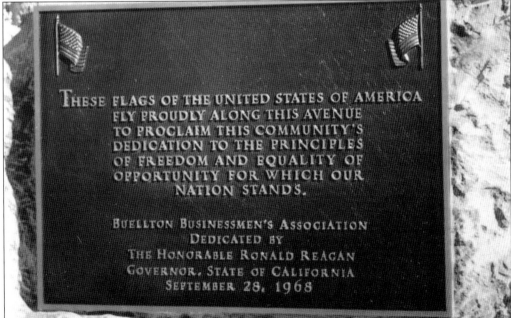

In the end, Buellton ended up with a parkway, complete with lights and flagpoles, running through the center of town. This stretch of the original Coast Highway, built in 1917, and dedicated as the last stretch of paved highway in 1922, was no longer the main route north and south. Now that it was dedicated to the town, one question still remained—what to do with it? Over the next 40 years, many solutions would be proposed to try and revitalize the service ghost town.

In the early 1970s, one of the more unique solutions for filling up the grass strips through the center of town came from the Western Roadster's Club. Actually the idea came from some of the local car buffs that lived in Buellton and were members of the club, including Jack Mendenhall, who realized that it was a perfect place for parking cars. This publicity photograph promoted the upcoming event.

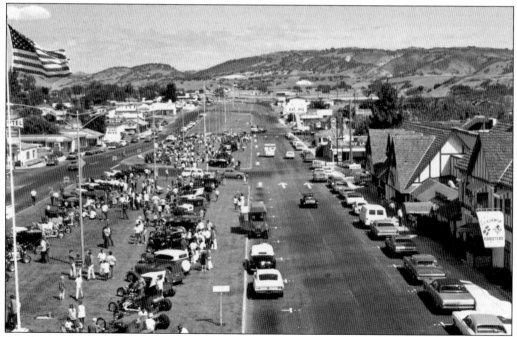

On the Avenue of Flags, mid-September 1971 proved to be a picture perfect time for Buellton to host a car show. The turnout was tremendous and the weather was perfect, leading to a succession of car events in Buellton over the next 40 years. Ironically, many of the vintage cars that had driven this early stretch of the Coast Highway were finding their way back to the old road.

108

Seven

ANDERSEN'S EXPANDED

In 1965, the town of Buellton was now sitting at a bypassed crossroads. A new stretch of the Coast Highway had been built to the east of the one-time booming service town, leaving the remaining businesses facing an empty road.

Trying to attract travelers from the easy on and off ramps of the new highway to the bypassed town presented a challenge. In addition, another challenge occurred at almost the same time, although it was not directly a result of the freeway bypass.

After over 40 years of ownership, the Andersens found themselves in some deep soup. An attempt at expansion and investments in canning their flagship dish had over extended their resources. The Andersens were forced to sell their namesake business, which now found itself at the corner of the empty crossroad.

This could easily have been the end of Andersen's. However, as fortune or luck would have it, there was a dynamic leader living nearby with the financial acumen and business savvy willing to take on the challenge.

Vincent Evans had served as a bomber on the Memphis Belle in World War II. After the war, he found his way into a career in the television and motion picture industry in Hollywood. By the 1960s, he had done well enough to semi-retire to the Santa Ynez Valley as a gentleman rancher. Evans was a dynamic leader, who arrived just at the right time to rescue Andersen's and help Buellton at a time when they needed a man with his skills and connections.

Evans spent the late 1960s at Andersen's, stabilizing the business and making plans for the next decade. With his plans in place, he was prepared to expanded the Andersen's chain beyond Buellton, but first he had ideas for helping Buellton succeed after the bypass.

Like Robert "Pea Soup" Andersen, Evans promoted contests to boost employee morale and promote pea soup. Evans, center, was known more for his shrewd business skills than being a fatherly owner as Andersen had, but he was still well liked and respected for his ability to make Andersen's succeed, especially at a time when it may well have failed.

Evans deserves credit for one of the most unique ideas for bringing business back into Buellton after the freeway bypass. Along with animal trainers to the stars, Ted and Pat Derby, Evans opened an animal park along the new highway in 1971. The Derbys trained animals were the featured attraction of this little theme park.

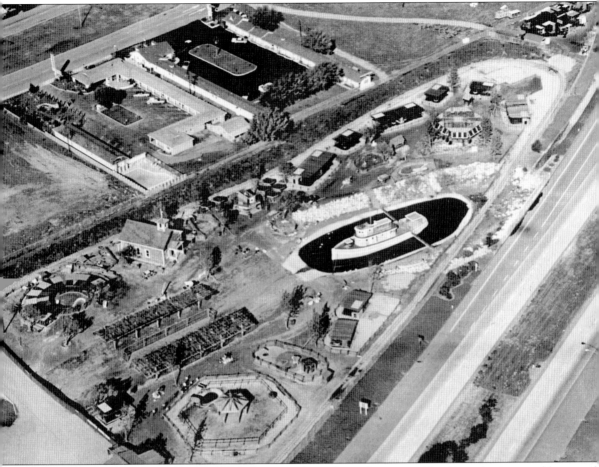

The Andersen's Animal Park featured a prop boat from the movie *Tug Boat Annie*, an old schoolhouse from the local area, and a narrow-gauge railroad that traveled around the animal attractions. Many of the animals had starred in television and movies including episodes of *Daniel Boone* and *Lassie*. The park was visible from the freeway and Evans intended it to draw tourist traffic to the restaurant and attraction to Buellton.

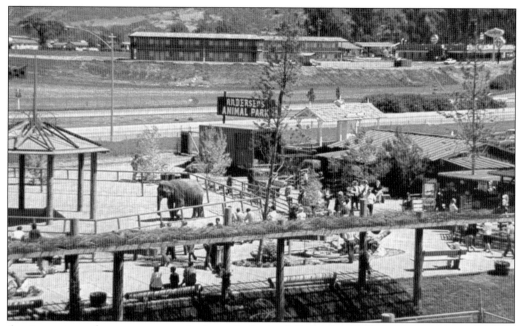

A view across the entrance to Andersen's Animal Park shows the new mini service town that had sprung up across the highway at the on and off ramps. The visibility of the animal park along the freeway was intended to draw traffic to the old highway, now known as the Avenue of the Flags, and Andersen's Pea Soup Restaurant. Fortunately many generations of California travelers knew about Andersen's and continued to make it a stop on their way up and down the coast.

Would an animal park in Buellton succeed? Unfortunately, like the train on this day, it derailed due to infighting among the owners and perhaps a lack of financial return. Fortunately it did not derail Evans plans for expanding Andersen's restaurants. It ended up as only a temporary bump in the road to much bigger things ahead.

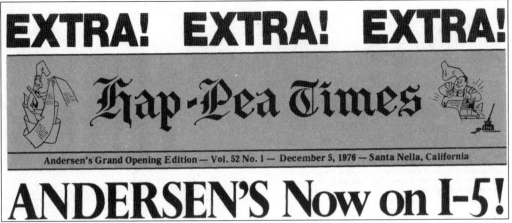

Like Robert Andersen, Evans had aspirations of expanding the pea-soup franchise to other parts of California. He opened a restaurant in Mammoth Lakes around 1972, primarily because he liked to vacation there and perhaps he thought that warm pea soup might be just the thing to serve to cold skiers. In Mammoth, though, was just a restaurant. The big news was launched in the bicentennial year in a little known place named Santa Nella.

Santa Nella was practically in the middle of nowhere. It was much like Buellton had been in 1924 when the original Andersen's restaurant opened. It was at a crossroads of a major north-south highway and a well-traveled, east-west crossing, just about the place where travelers needed to stop to eat, get gas, and go to the bathroom. As odd a location as it seemed at the time, it was well placed to capture traffic on the Golden State Freeway between Los Angeles and Sacramento.

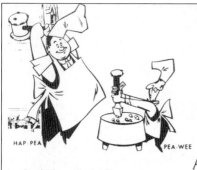
Evans envisioned and ultimately created his own service town in Santa Nella. The restaurant, gift shops, hotel, and service station, all built at the same time, created an oasis on this long stretch of Highway 5. The Andersen name was already famous from the giant billboards on the Coast Highway and restaurant in Buellton, so it was not a tough sell to the traveling public in the central part of California by 1976.

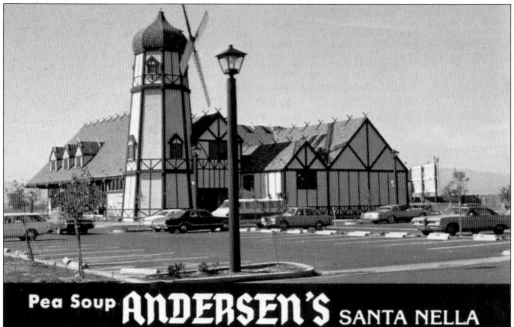

Pea Soup ANDERSEN'S SANTA NELLA

Like Buellton and much of Solvang, the buildings in Santa Nella featured traditional style Danish architecture, including a windmill and crosshatched roofs to ward away evil spirits. As kitschy as it seemed in the middle of who-knows-where, it worked, attracting a steady stream of business that would keep it busy for at least the next 30 years and into the future.

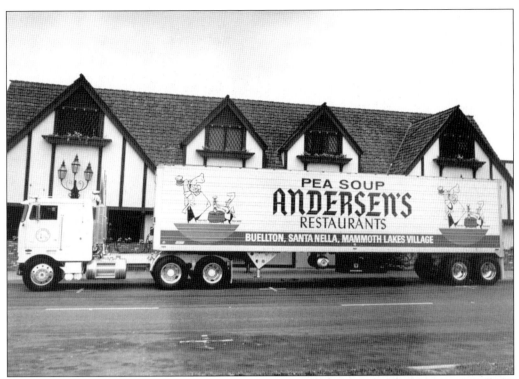

By the mid-1970s, Andersen's Pea Soup was available at three locations. Evans created a traveling billboard in the form of a semi truck to promote the pea soup and carry supplies between the locations. Now that the central and northern part of California was covered, Evans began looking south to open another location.

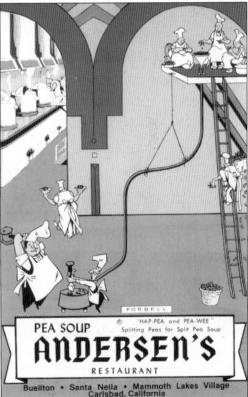

The now internationally known cartoon postcard featured a list of locations by the end of the 1970s. Andersen's traveling ambassadors, Hap-pea and Pea-wee, traveled the globe via the mail service, while a semi truck and billboards promoted pea soup throughout California. Evans also found his southern location near San Diego in Carlsbad along the Golden State Freeway, adding it to the Andersen chain around 1979.

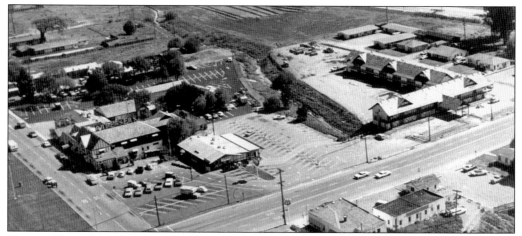

Vincent Evans brought a new vitality to the Andersen name as he built his pea soup empire. Despite the failure of the animal park in Buellton, other ventures, including the restaurant in Buellton, were succeeding by the end of the 1970s. In 15 years, Evans had positioned the Andersen chain for the future—a future that would likely include further expansion and growth. After 55 years in business, things were looking bright for the little diner that opened on the Coast Highway in 1924 in Buellton.

Evans services set for 11 a.m. today

By KING MERRILL
Valley News Staff Writer

Services at the graveside for Vincent Brooks Evans, 59, his wife, Margery Elinor Evans, 58, and their daughter, Venetia Claire Evans, 22, who died in a plane crash north of Buellton Sunday evening will be conducted today (Thursday) at 11 a.m. at Oak Hill Cemetery in Ballard.

Father Charles Stacy, rector of St. Mark's-in-the-Valley Episcopal Church, will officiate.

Evans, a leader in the Santa Ynez Valley business, political and cultural areas of the Valley, was born Sept. 6, 1920 in Fort Worth, Tex. He attended North Texas Agricultural College in 1937 and North Texas State Teachers College from 1939 to 1940. He taught school for a period, worked for a trucking line and at

one time was a shrimp fisherman.

He joined the U.S. Air Force in 1942 and served as a bombardier with Gen. Emmett (Rosey) O'Donnell's air crew aboard the "Memphis Belle," and flew in the initial Air Force B-29 raids on Japan. Evans attained the rank of major and received the Distinguished Flying Cross with four oak leaf clusters, the Air Medal of Honor and other awards.

Toward the end of the war he met and developed a strong friendship with Ronald Reagan. Through the ensuing years, Mr. Evans gave support to Reagan politically and had only recently been named a member of Reagan's county steering committee.

Commenting on the death of Evans, Reagan in a prepared
(Continued on Page 11A)

Sunday, April 20, 1980, proved to be a fateful day for the Evans family and the future of Andersen's Pea Soup. Returning home from a trip, their small plane crashed just short of the Santa Ynez Airport killing the entire family. An unclear will left the Andersen's chain in limbo for many years to come. The restaurants in Santa Nella and Buellton would survive, just as the Buellton location had survived the relocation of a major highway and the loss of the Andersens as owners in the 1960s. Who knows just how far Andersen's would have expanded had Evans lived to further his vision for the pea-soup empire?

Eight

THE PEA SOUP SPECIALS

In a town of service station owners, it was inevitable that racing would become part of the local heritage. The station owners and mechanics had to have something to do when they weren't servicing the customers' cars. In a town with 10 or 12 gas stations that was dependent on tourist traffic, they often found themselves with idle time on their hands.

Particularly after World War II, there were mechanically inclined men in town with training courtesy of Uncle Sam. These young motor heads not only liked to build cars, they liked to race them too.

Some of the elder service station owners and mechanics had been competing in Model T races in Lompoc. In 1936, a group of Lompoc racers got together and formed a Model T racing club to sanction their local races. They started with street races until they were strongly encouraged to seek out a racetrack away from the public roads. The oval track was actually better for the spectators, and if the car broke down, the driver was not out of town somewhere, like on a road course.

The first oval tracks were carved out of farm fields between crops or pastures wherever they could get someone to agree to let them race. By the mid-1940s, the Lompoc club opened their races to outsiders from nearby Buellton. They were probably tired of racing each other and wanted some new competition. Some of the early Buellton drivers and mechanics included Tommy Garland, Bill Olivera, and Chris Christianson of Solvang. Buck Rielly and Richard Ray later joined.

It was from this group of racers, and probably a few others, that the idea of establishing a track in Buellton was formed. After World War II, circuit racing became more popular and the T Club envisioned a series of tracks to expand the racing opportunities. Buellton was a logical choice based on proximity to Lompoc and the Coast Highway to attract other racers from points north and south.

Around 1950, the first races were held at the new Buellton Speedway. Where was this speedway and how did it influence Andersen's Pea Soup Specials? Let's take a trip back in time when races were run and cars were built in Buellton.

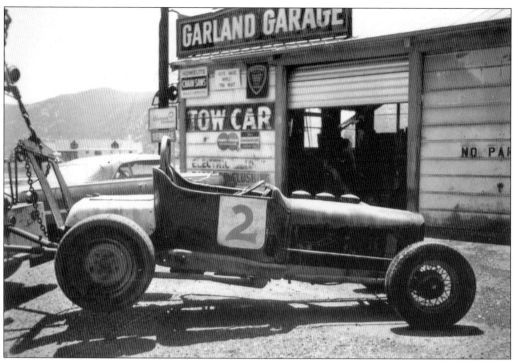

A familiar site around Buellton, Tommy Garlands No. 2 car was dragged behind his tow truck to the races in Lompoc or the nearby Buellton track. Not one of the prettier cars on the track, it still ran well.

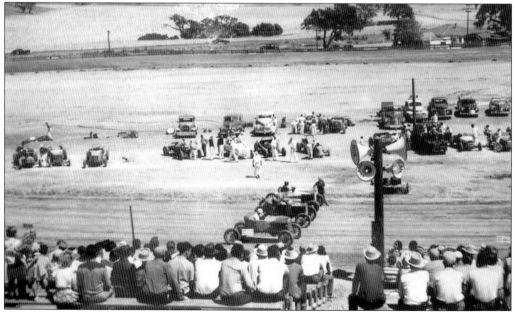

The Buellton Speedway was located just to the west of Highway 101 behind the Dining Cars Café. In fact, it was the original owner of the Dining Cars Café, Ed Mullens, that leased the land for the track to the Lompoc T Club. The spectators sat in stands carved into the hillside above the flat oval track. In this race, vintage Model Ts get ready to run.

This is the cover of one of the few known programs from the Buellton Speedway for a June 1950 race. Vintage Model T jalopies, hot rods, and motorcycles were run at the track according to the program. From the two programs that exist, it's known that races were run in the summers of 1950 and 1951 at least.

'T' Club Speedway

Buellton, California

presents

HOT ROD RACES

| OFFICIAL PROGRAM | NEXT SUNDAY JULY 2 | TEN CENTS |

Sanctioned by Lompoc Model-T Club

June 25, 1950

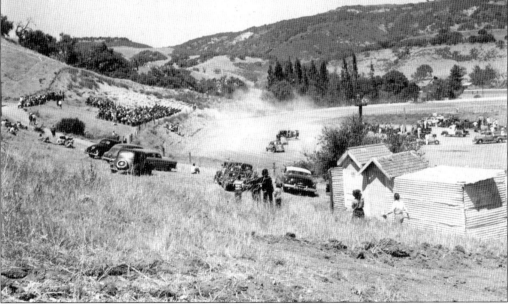

The Speedway didn't last long, probably in part because of crashes like this. The flat oval made the top-heavy coupes more prone to rollovers, creating liability for the landowners and sponsors. However, the legacy of racing lived on in Buellton, partially because of the impression it left on a young local named Jack Mendenhall.

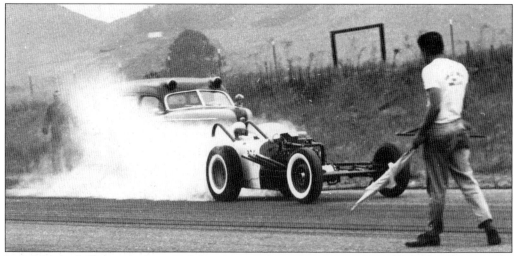

Jack Mendenhall was fresh out of the navy and too busy getting established to race at the Buellton Speedway. However, the racing action left an impression on him. He leased Bill Olivera's Richfield service station, where Bill stored his own Model T racer. Jack had dreams of building and driving fast cars, but at the time, he may not have dreamed that he would build the very first "Pea Soup Special."

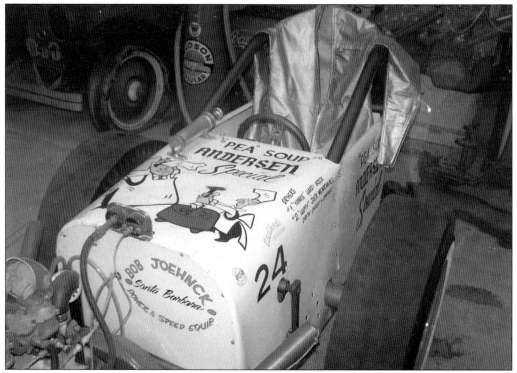

In the early 1960s, Mendenhall teamed up with the grandson of Andersen's founders, Robby Andersen, and built a drag car to run at the tracks in nearby Santa Maria and San Luis Obispo. Jack and Robby managed to talk Robby's father, Robert "Pea Soup" Andersen, into sponsoring their creation and the first pea soup-powered special was born. It turned out to be the first of many specials to come.

The Pea Soup Specials were emblazoned with the likenesses of Andersen's ambassadors, Hap-pea and Pea-wee. Pea-wee now had more to be terrified of than the giant mallet as he raced down the quarter mile track at high speed. For Mendenhall, the pea-soup sponsorship was a great way for him to build cars. For Andersen's, it provided some local promotion that was good for business.

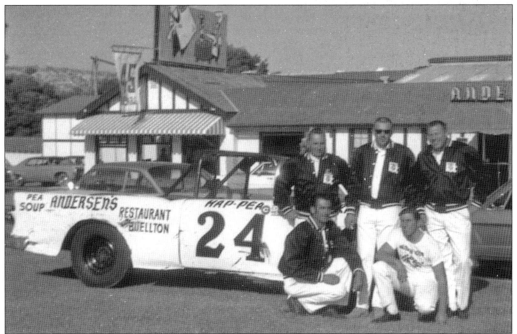

Mendenhall's relationship with Andersen's continued as he created new Pea Soup Specials. He moved from the drag track to the circle track, building a series of cars designed to run on the dirt oval in Santa Maria. Pictured here with the pit crew in front of Andersen's is his stockcar Piranha IV.

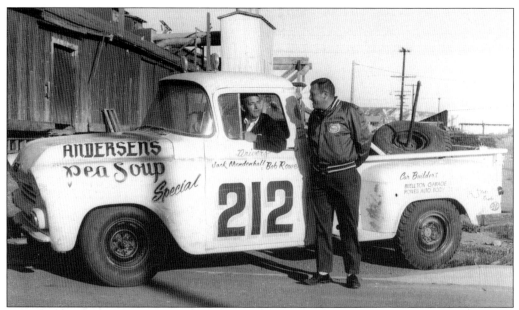

As if dragsters and track cars weren't enough, Mendenhall moved on to the Baja road races, building an off-road race truck for the desert endurance race with Bob Rowe. By now, Andersen's had been sold to Vince Evans, who willing carried on the tradition of the Pea Soup Specials, sponsoring all kinds of cars, including a stockcar team with driver Slick Gardner.

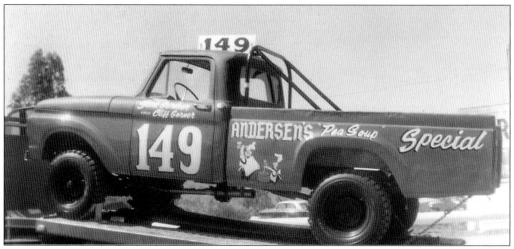

Slick Gardner got in on the Baja action running this truck with Cliff Garner. And if the last names aren't confusing enough, Mendenhall also helped build a Baja car for actor James Garner.

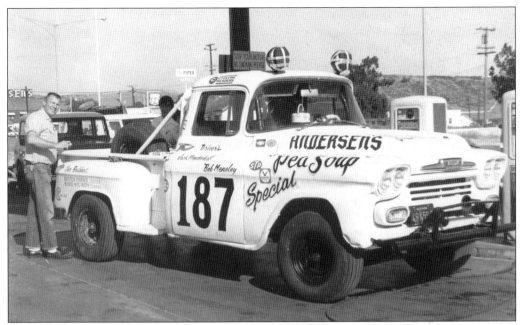

Jack rebuilt his Baja race truck and ran it another year with Bob Meneley. Another pea soup-powered special, designed to run in the land of frijoles, fills up with real gas at Mendenhall's Richfield station before heading south of the border.

By the 1970s, Hap-pea and Pea-wee were world-class racers. They had traveled throughout the United States on a race boat and been south of the border on Baja cars and trucks. The small town of Buellton was a racing mecca of Pea Soup Specials and race vehicle builders. The Pea Soup Specials would end with the death of Andersen's owner Vincent Evans in 1980, but there was one more super fast special yet to come.

Andersen's Sponsors Auto, Water Racers

The relatively small community of Buellton, home of Andersen's Split Pea Soup, has produced some of the nation's top auto and water racing drivers. And, all, at one time or another, have been sponsored by Andersen's.

IN THE AUTO racing department, Pea Soup Specials have been manned by movie and television star James Gardner, rancher Slick Gardner, automotive specialists Jack Mendenhall, Mark Mendenhall, Bob Meneley and others in a number of top west coast competitions.

At various times they have joined forces to compete in a pair of grueling events; the Mexican 1,000, described as the "roughest race under the sun," as well as the equally challenging Baja 500.

Although they have not emerged as winners, all of the Andersen's sponsored cars and drivers have usually finished among the dozen or so leaders in their respective fields. .

IN THE FIELD of water racing

an 18-foot Mandella craft, now placed in the new Grand National Marathon classification for 100-mile races, Bill Olivera, Pete Minetti and Bob Bruhn completed regularly throughout the country under the banner of Andersen's Pea Soup Special.

All three have now retired from the water racing competition but for years they took part in major events in Miami, Tennessee, Texas and California. Their Mandella, which is now used for pleasure purposes, contains a 467-cubic inch Chevrolet engine of 675 horsepower. It is fuel injected, has a capacity of 200 gallons of gasoline and is capable of a top speed of 100 miles per hour.

Co-workers at Andersen's at both Buellton and Mammoth Lakes are sports-minded, too. Many are members of organized bowling leagues in Buellton and at Mammoth Lakes take part in both winter and summer competitive sport activities.

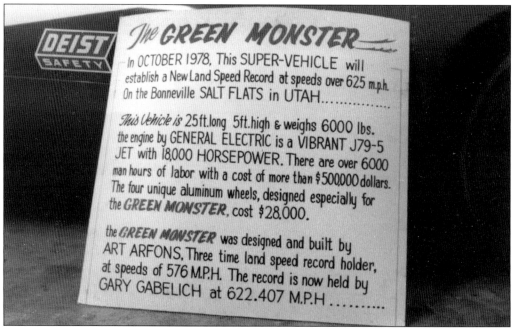

The GREEN MONSTER

In OCTOBER 1978, This SUPER-VEHICLE will establish a New Land Speed Record at speeds over 625 m.p.h. On the Bonneville SALT FLATS in UTAH..............

This Vehicle is 25 ft. long 5 ft. high & weighs 6000 lbs. the engine by GENERAL ELECTRIC is a VIBRANT J79-5 JET with 18,000 HORSEPOWER. There are over 6000 man hours of labor with a cost of more than $500,000 dollars. The four unique aluminum wheels, designed especially for the GREEN MONSTER, cost $28,000.

the GREEN MONSTER was designed and built by ART ARFONS. Three time land speed record holder, at speeds of 576 M.P.H. The record is now held by GARY GABELICH at 622.407 M.P.H

Jack Mendenhall's Pea Soup Special dragster was the first of the specials. Slick Gardner's "Green Monster" would be the last. It would also be the fastest, with plans to travel over 625 miles per hour and set a new land speed record. Rather than a car, it was a jet on wheels, built for the salt flats at Bonneville.

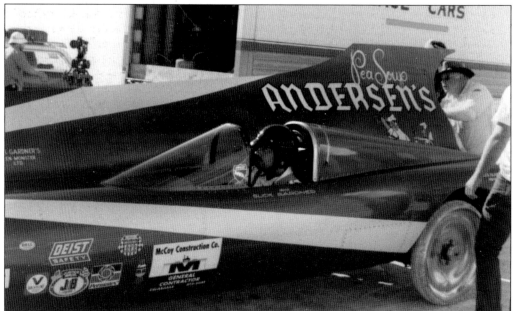

As promised, the Green Monster made its maiden voyage to Bonneville to attempt to become the fastest car on earth. No matter what the outcome, it would be the fastest Pea Soup Special served up in the racing world. Unfortunately, the car veered off course on its first run and almost didn't stop. The land speed record remained unbroken, but the world's fastest Pea Soup Special was a fitting end to the racing tradition at Andersen's.

Nine

Buellton Today

When the new freeway bypassed Buellton in 1965, a town that relied on Coast Highway travelers found itself sitting on a side street empty of the traffic that it depended upon for its livelihood.

Some of the service stations were relocated to the off ramps next to the new freeway, others closed, and a few gritted it out, surviving on auto repairs and towing service. The motels did a modest business, although most of the tourism had shifted to Solvang where numerous hotel rooms were now available. Andersen's Pea Soup could still draw a crowd due to its longevity and widespread reputation with previous generations of coastal tourists.

Aside from the occasional car show or local event, the Avenue of the Flags was just a wide, grassy median through the center of what was once Highway 101. For more than 30 years, the town struggled with the empty avenue and how to reinvent itself into something other than a service town.

Under the supervision of the Santa Barbara County government, rather than a localized city control, there was very little progress being made. In 1992, an initiative was passed making Buellton an incorporated city and giving control to the local citizens.

Since that time, Buellton has grappled with the challenges of cityhood and growth. Today the city has evolved into a bedroom community for Santa Barbara and Goleta, 30 miles to the south. The city still supports service industries and has grown from recent commercial development and expansion.

As the city fathers look to the future of the community, its citizens hope that they will remember to glance back through the windows of the past and remember the history and heritage that brought Buellton to where it is today.

The City of Buellton was incorporated in 1992, the same year that the Buellton Historical Society was established to record the heritage and history of the town. Today both organizations are flourishing, as Buellton looks to its past to help determine its future place in history.

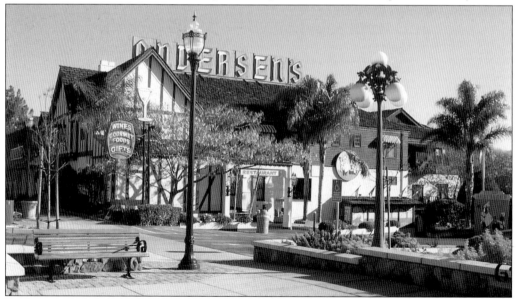

Andersen's is still the home of the famous split pea soup, outlasting a major highway while serving the dish that has determined its destiny since 1924. In 1999, a local restaurateur, Milt Guggia, brought the ownership of Andersen's back to the area. Steady improvements have been made to recapture the luster of Andersen's golden years. The Santa Nella location, established by Vince Evans, still holds its place on the Golden State Freeway as well, under separate ownership. After more than 80 years, Andersen's is still firmly planted on its foundation of split pea soup.

What to do with an empty avenue? That question has been explored since 1965 when the highway left the center of town. Recently the City of Buellton installed new landscaping, walkways, and beautiful bronze sculptures on this Avenue of the Flags, dedicated by Gov. Ronald Reagan in 1968. The sculptures pay tribute to this historical dedication and honor the symbol of America—the star spangled banner.

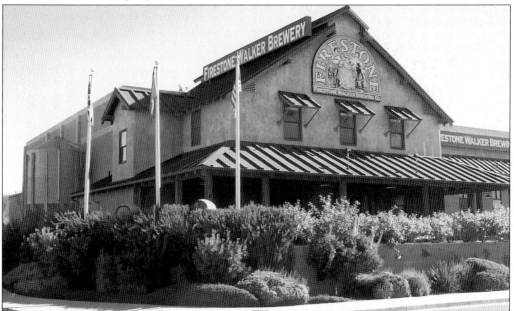

In the 1970s, the Firestone family established their flagship winery in the Santa Ynez Valley. More recently, the second generation of local Firestones expanded into the brewing business, opening a microbrewery and restaurant along Highway 101 in Buellton. This business, like Andersen's in the past, shows promise for the future of Buellton and the generations to come.

Across America, People are Discovering Something Wonderful. *Their Heritage.*

Arcadia Publishing is the leading local history publisher in the United States. With more than 3,000 titles in print and hundreds of new titles released every year, Arcadia has extensive specialized experience chronicling the history of communities and celebrating America's hidden stories, bringing to life the people, places, and events from the past. To discover the history of other communities across the nation, please visit:

www.arcadiapublishing.com

Customized search tools allow you to find regional history books about the town where you grew up, the cities where your friends and family live, the town where your parents met, or even that retirement spot you've been dreaming about.